Jesus
doesn't
Care About
Your Messy
House

Jesus *doesn't* Care About Your Messy House

HE CARES ABOUT YOUR HEART

DANA K. WHITE

W PUBLISHING GROUP

AN IMPRINT OF THOMAS NELSON

Published in Nashville, Tennessee, by W Publishing, an imprint of Thomas Nelson.

Author is represented by Jenni Burke of Illuminate Literary Agency, www.illluminateliterary.com.

Thomas Nelson titles may be purchased in bulk for educational, business, fundraising, or sales promotional use. For information, please email SpecialMarkets@ThomasNelson.com.

ISBN 978-1-4003-4437-6 (TP)
ISBN 978-1-4003-4440-6 (audiobook)
ISBN 978-1-4003-4439-0 (ePub)

Library of Congress Control Number: 2024944763

Printed in the United States of America
24 25 26 27 28 LBC 5 4 3 2 1

To Jackson, Reid, and Presley. Thanks for
confirming that God's unique design is better
than anything I could dream up.

Contents

Start Here: About That Title . ix

PART 1: CLEANLINESS IS NOT A SPIRITUAL ISSUE

1. Jesus Cares About Your Messy House If You Do 3
2. Why It Feels Like Cleanliness Is a Spiritual Issue 17
3. What Jesus Actually Said About Cleanliness 37
4. Technically Helping Versus Actually Helping 49
5. Magic Versus Miracles . 67
6. The Myth of Arrival . 81
7. One Size Doesn't Fit All Hearts 95
8. Paying for Toothpaste Isn't a Sin. 105

PART 2: CLEANLINESS IS A SPIRITUAL IMAGE (NOT A SPIRITUAL ISSUE)

9. Eliminating the Schtank . 121
10. "How I'm Made" Versus "Just the Way I Am" 135
11. (Don't) Deny Reality. 151
12. So What (Exactly) Counts? . 161
13. Twenty-Year-Old, Brand-New Tires. 171
14. Happily Sometimes After . 179

Contents

15. Logs, Specks, and Cheese Stains 193

16. When It's Jesus at the Door . 203

One Last Important Word: Community 211

Acknowledgments . 213

Notes . 217

About the Author . 219

About That Title . . .

Jesus doesn't care about your messy house. If that statement makes you feel weird, don't worry. I'm going to use the next sixty-thousand-ish words to explain, but I'll give you a few spoilers now.

This is a book about experiencing God's grace, using an oddly specific, strangely divisive example from my own life. This particular example feels both too unimportant and too daunting to be *the* example, but it's the example God gave me to share.

People tend to react to a book's title and assume they know what's inside. They read one paragraph or a single page and are convinced they "get it." If you're going to remember only one thing from this book, though, I want it to be this: *Jesus cares (deeply, desperately, passionately) about you.* If you've cried yourself to sleep over your messy house, He cares about those tears. If you've flushed with shame while making an excuse to a friend who asked to stop by, Jesus understands. If you've prayed, begging Him to change you and your home, He hears those prayers. He's in the process of answering them, right now.

Cleaning up a messy house is a good thing. I've spent over a

decade working on mine and teaching others what I've learned. But if your goal is to get your home clean enough to please God, that's a problem. Your house can never be clean enough to please God, not because you can't scrub hard enough or get rid of enough clutter, but because He was never looking for a perfect house in the first place. Thinking a clean house is what Jesus wants from you, or that He's mad at you because your house is messy, means you are missing what He *does* care about.

Jesus doesn't want anything to take your focus away from Him. He doesn't want you to depend on or rest in anything other than Him. Even good things—like getting your house under control—can cause your heart to get off track, and Jesus cares very much about your heart. Your heart is the rudder or the steering wheel or whatever metaphorical device helps you understand that your heart is the core of *you*.

My messy house was once my deepest, darkest secret. The state of my home caused me intense shame. I dreamed that some-day I'd get it organized, but many somedays came and went and an organized house didn't happen. I sorted and re-sorted and arranged and rearranged, but my home constantly fell back into Disaster Status. No matter how hard I scrubbed or how many bins, baskets, or buckets I purchased, I couldn't do it. I could not make the changes stick.

In 2009, after a desperate and angry prayer asking God why He hadn't cured me of the chronic messiness I'd begged Him to fix, I started a blog called *A Slob Comes Clean*. I was desperate to be a writer. I wanted to write to encourage women, but I didn't want to live in fear that someone might find out what my house looked like. *A Slob Comes Clean* was supposed to be my practice blog. I thought I'd journal there for a few months, and once my

house was under control, I'd start another blog about things I felt qualified to share. I wasn't teaching anything. I was just figuring things out for myself.

Anonymously, of course. I wasn't *wacko*.

As I wrote, I analyzed what I was doing and not doing, what I was thinking and reasoning and failing to notice. I worked on one habit at a time, figuring out how to work the habits into my day and learning which ones made the biggest impact. I decluttered my way through cabinets and closets and felt lots of feelings as I purged boxes full of treasures and truckloads full of junk. My home improved, and I learned a lot about myself. I figured out why this type of thing (dishes, laundry, dining room tables that grow random piles of stuff) was difficult for me and how to solve these problems.

I was also surprised, though, by what did *not* happen. I assumed that at some point, God was finally going to reveal some big spiritual truth about my clutter or my messy kitchen. Isn't He a God of order? Isn't cleanliness next to godliness? I just knew there had to be a Bible verse or spiritual principle I was missing that would make all this homemaking stuff finally click for me.

But that is not what God showed me as I worked hard, thought hard, and prayed hard. Instead, God showed me that He made me. I'd known I was His creation since my preschool Sunday school class. What I didn't grasp until my thirties, though, was that He made me . . . me. Quirks and all. He purposefully gave me the ability to hyperfocus on one thing while I let a million other things slide for the sake of that one thing. God had a plan when He designed me with the ability to become obsessed with every little detail when directing a play but also

with the ability to walk past a sink full of dirty dishes without even noticing them. *For several days in a row.*

These days, my sink is (usually) no longer piled with more than one day's worth of dishes. I have hauled truckloads of clutter out of my home. I almost never pretend I'm not home when the doorbell rings. I've discovered my Clutter Threshold, and I've calculated Dishes Math. I've written entire books on the subject of housekeeping, using made-up-by-me terms like Clutter Threshold and Dishes Math.

Through it all, God has shown me that my messiness issues are not spiritual issues. They're just my struggles, and having a struggle is part of who I am as a human and who you are as a human. People who *do* notice a sink full of dirty dishes struggle with something else. Every person reading this book struggles with something.

I'm fairly sure God hasn't called most of you to make careers out of exposing your deepest, darkest secrets, but I am absolutely confident He wants you to let your struggle draw you closer to Him. He wants to use your unique struggle to show you how and why He made you the way He did. Your struggle can help you understand God more, and knowing God more is a beautiful thing. Knowing Him more brings so much gratitude into my heart that it (almost) makes me thankful for my struggle. If the choice is between having a perfect house or knowing God, I choose God. It's about Him, not about the struggle. God used my struggle to move me from head knowledge to deep-hearted understanding of many aspects of my relationship with Him. I pray this book will help you understand some of these things in less time than it took me.

Part 1

Cleanliness Is Not
a Spiritual Issue

Chapter 1

Jesus Cares About Your Messy House If You Do

*J*esus cares about your messy house if *you* care about your messy house. If your heart hurts because your guestroom is filled with boxes and you had to make up an excuse so your mother-in-law would stay in a hotel, He cares. If you're bewildered by never-ending piles of laundry that you could've handled easily in an earlier phase of life, He sees the tears that threaten to spill. If you're desperate for adult conversation but have to cancel your playdate when it rains because you're too embarrassed to let your friend inside your house, Jesus' heart aches for your heartache.

Jesus sees your pain, whatever struggle is causing it. The purpose of that pain, of that struggle, is to draw your heart in line with His heart. I wanted a spiritual cure for my ongoing messiness problem. Instead, what I got was a better understanding of who I am and who Jesus is and how He designed me to fit into a relationship with Him.

I'm passionate about this message and the potentially disconcerting book title because as I read through the words and life of Jesus, I see how absolutely crucial it is to stop turning things that aren't spiritual issues into spiritual issues. Having clutter is not a spiritual failure. There are reasons why clutter happens more often and in greater measure for some of us than others. Understanding those reasons helps. There can be a spiritual factor, but it is not a spiritual failure.

An ongoing struggle that feels unsolvable is all-consuming. The angst, frustration, and constancy of the struggle keep it at the top of the list of problems to beg God to solve. As I walked through my deslobification journey, God shifted something in my heart that changed my prayers. He showed me that He wanted me to give Him my struggle. Instead of begging Him to change me, He wanted me to give Him all of me. God wants you to give Him your struggle. He doesn't want you to try to hide your struggle from Him, even if you've gotten really good at keeping it secret from everyone else. He wants you to give Him the struggle you've never considered He might want: the one you're confident He could never use. He wants you to be willing to let Him do *whatever* He wants to do with that struggle, even if that means *not* taking it away.

Jesus cares deeply about your heart. Effort pleases God only if it comes out of a heart that loves Him and desires to know Him more. Knowing God more means understanding that effort isn't what makes Him love you.

Stop focusing on things that *don't* matter as if they are things that *do* matter.

Your weakness, your struggle, your pain, whatever it is, helps you understand that you need God. Believing this can be hard, but your weakness is a gift.

This Book Is for You . . . No Matter Why You Are Here

If you'd asked me fifteen years ago to name the very last subject I'd ever write a book about, I immediately would have said, "Housekeeping."

If you'd told me I would one day write a book about housekeeping *as it relates to my relationship with Jesus,* I would have definitely envisioned a much different book from the one you're reading now. I'd have assumed a book about Jesus + housekeeping would include a list of Bible verses that would remove all my bewilderment over the state of my home. I'd read a verse, say, "Oooohhhh, that's what I've been doing wrong! Thanks, Jesus!" and my bathtubs would sparkle from that moment forward.

This book is definitely not a how-to guide on getting your house under control. I've already written those. In the opening section of my first book, *How to Manage Your Home Without Losing Your Mind,* I was pretty blunt. Like, DO NOT READ THIS BOOK if you don't struggle (big-time) to keep your house out of Disaster Status. When I wrote *Decluttering at the Speed of Life,* I knew decluttering was a more universal topic. Everyone everywhere has to get rid of stuff. I made it super clear, though, that I wouldn't be sharing how to make things pretty or perfect. I was there to teach you how to dig your way out of your stuff.

This book is different.

This book is for you if you felt relieved at the title because you immediately understood what it meant—you know all too well the weight of worrying what Jesus thinks about your house. You know your house isn't Jesus' measuring stick, but you've never put that thought into words. I've got words for you. Lots and lots of words.

This book is for you if the title made you mad because you've spent years working on your home and it's the one thing you've got down. You have other problems you worry might make Jesus mad, but your house isn't one of them. You focus on your house when you need to make yourself feel better. Housekeeping is the task you tackle in order to squash your panic over the other things you can't figure out how to change.

This book is for you if the title made you feel uneasy because you've tried to help someone who couldn't seem to "get" how to keep their home from becoming a disaster. You couldn't get why they couldn't get it. *Them not getting it* plus *you not getting why* hurt your relationship. Maybe you put a spiritual spin on your advice and implied that Jesus cared very much about their messy house.

This book is for you if you reacted to the title by immediately and completely disagreeing with it. Don't worry. There's a lot to dive into here, so you'll have more chances to decide if you agree or you'll walk away feeling more confident in your disagreement.

This book is for you if you have worked and worked on your home and don't like the title because you've been trying to do what is right. You believe your efforts matter. They *do* matter. They matter so much that I've written three entire books about how to get a home under control.

This book is for you if your response to the title is, "Well, of course He doesn't!" Thanks for the affirmation, and I hope you appreciate the gift you have in your understanding. I hope this book deepens your confidence and gives you words to share with those in your life who need your encouragement.

This book is for you if you're feeling hopeful, scared, or both when it comes to the state of your house. This book is for you if you've spent many weekends (or Christmas vacations)

top-to-bottom cleaning, only to be surprised by the reappearance of disaster on Tuesday morning (or on January 2). This book is for you if you can't count the number of times you've declared that things in your house are finally going to change—but that change never sticks.

Most of all, though, this book is for My People, the ones who have already read everything I've ever written and may or may not care if Jesus cares about any of it. Welcome to my long-winded explanation of where Jesus fits into the subject of cleaning because, if you already know me, you know He's part of everything in my life.

So What's the Link Between Cleaning and Jesus?

When I wrote my first two books, I was adamant they not include spiritual content. I was adamant because so many people who love Jesus have written about cleaning, organizing, and home management from a spiritual perspective, and even if they didn't mean to imply that having an orderly home was what Jesus requires of ~~Christians~~ Christian women, a lot of people reading their words felt that way.

I'm going to make two seemingly contradictory statements here: Cleaning is not a spiritual issue. Everything is a spiritual issue.

Everything is a spiritual issue because God cares about every single aspect of our lives. Not because He expects us to be amazing at every single aspect of our lives but because He wants us to give Him our hearts. And that includes giving Him every single aspect of our lives.

I've heard people talk about how they had to learn that God loved them even when their homes weren't perfect. He showed them the futility of striving for His approval by scrubbing their grout or dusting behind the fridge. He wasn't disappointed in them because their houses weren't shiny and straight at all times. They're right, and their messages are important.

This time, though, the same message is for a different audience, from a very different angle. I know from personal experience that a whole segment of the population, both Christian and non-Christian, can't relate to the way that message is usually shared. Our problem is not that we can't stop cleaning but that we are too overwhelmed to start. People Like Me are frustrated and bewildered over something that seems like it should be easy but instead is incredibly hard for us.

Some of us used to be organized, but life changes (kids, aging parents, stressful jobs) mean the ways we used to handle our homes don't work anymore. Some of us have ADHD; some of us have chronic health problems; some of us have trauma. Many of us have always struggled without any idea why we struggle. Most of us have more ideas about interesting things to do than we have space to put the stuff in that we think we need to do those things. We can't relate to someone who is relieved to learn it's okay to leave the dishes undone instead of staying up until two A.M. deep-cleaning the kitchen out of fear of God's disapproval. We're glad for the mom who realizes it's okay to let the neighbor come inside before putting the kids' toys back in their toy box, but the example makes us feel worse, not better.

People Like Me have three toy boxes, they're all overflowing, and the floor is *still* covered in toys. We've already found two more toy boxes on Facebook Marketplace and have arranged a

pickup for one of them. And that still won't be enough to get all the toys off the floor. We never even think about cleaning the kitchen until someone texts to say they are coming over and we realize we haven't washed a dish in three days. The thought of letting people into our homes without a two-week warning causes actual heart palpitations.

This book is for the person who hears about someone who needs to loosen her grip on perfection and thinks, *I'd love to have that problem.* I write for the person who can't even get a grip on her house, who feels like she's sinking in quicksand, who has absolutely no idea how the mess keeps reappearing. I've been there, and I'm here for you. I *am* you. I'm the person who tried for years and could not figure out how to have a house that wasn't a disaster. I believed I was defective, flawed, and inept. My problem wasn't that I couldn't let go of perfection but that I felt inherently incapable of handling my house at all.

But God.

God showed me that the way I'm wired is beautiful to Him. How my brain works is exactly how He wants it to work. His plan, all along, was for me to help others whose brains work exactly the way He designed their brains to work.

I'm not a theologian and promise not to pretend to be one in this book. I am, however, a woman whose heart and mind and life have been changed by studying the Bible. Not coincidentally at all, I started truly studying the Bible less than a year before starting what I refer to as my "deslobification" process. Over the same period of growing spiritually in confidence and understanding, I went from pretending not to be home when the doorbell rang to usually being the first to offer my home when a need arises.

Feel free to question what you read in this book, but look for

answers in the Bible. Go read the passages I cite. Read the verses (and whole chapters) before them and after them, and pray. Ask God to help you see and understand His Word, even if it feels weird to ask. I promise you, it's His very favorite question, and one He promises to answer.

I'm not going to ask you to agree wholeheartedly with everything in this book, but I am asking you to consider. Some of my incorrect assumptions about God came from being taught incorrect or incomplete things. Most, though, were due to the filter of shame through which I'd heard truth. I will understand more in another fifteen years if I keep studying Scripture, but what I know now has great value and is important to share.

Ultimately, this is a book about my own spiritual growth, which happened to coincide with my growing understanding of how to keep a house under control. Learning more about myself while learning more about God brought so much into focus. My weaknesses and failures are opportunities to better understand God's grace.

I'm willing (finally) to call myself a Decluttering Expert, but I always try to be clear that I teach strategies I know work because I've lived them. That's my promise in this book too. I know these spiritual truths to be true because I've lived them.

Supremely Unqualified

I am uniquely qualified to write this specific book. I understand the struggle of being chronically disorganized. I've been bewildered by the shame. I've led many thousands of women through real change in this specific area. It's a weird thing to be a

published author (something I'm very excited to be) whose book titles give people completely wrong impressions about what you do for a living. Logic would say that someone who writes about such things must be super organized. But God doesn't worry about logical sense, and He likes to use my life as an example.

Here's my backstory for those of you who don't know me. For those who do, it's a refresher. I grew up messy. Much to my mother's dismay and despite her creative attempts at instruction, discipline, and endless failed reward systems, I was hopelessly messy. I didn't like being that way. I hated being late because I had been searching for a lost shoe in piles of random stuff. But I didn't *worry* about it. I had a go-getter personality and felt competent at most things I cared to try. If I didn't care about something, I didn't worry about not being great at it. I'm not an overachiever for the sake of overachieving.

I like to impress teenagers with the fact that I played varsity basketball as a freshman in high school, but the full story is significantly less impressive.

I was a cheerleader in junior high and high school. I cared about being a cheerleader. As a little girl, I had a *book* about cheerleading and learned every stretch, cheer, and chant in that book. When my brother played YMCA basketball and football, my dad was his coach. This let me go legit in my cheer aspirations. I recruited friends, designed T-shirts (a much bigger deal in the '80s than it is now), and required my T-shirted friends to attend practices. (I was the cheer coach, of course.) We cheered from the sidelines and took to the field at halftime. I look back now in wonder that I felt so free to do all of that as an eight-year-old, but it was the most natural and logical thing in the world to me at the time.

Only after I'd been organizing my own squad for three or four years (when I was, at most, in the third grade) did our local Y get the idea to form cheerleading squads for the elementary-age football teams. I clearly remember my mother (whose support, I assume, was my enablement) informing the woman at the Y's front desk that my brother's team already had a squad and wouldn't need one provided. Once I became a "real" cheerleader in seventh grade, cheering was my entire life for several years.

I bring all that up to make the point that I was a tackler. Not football tackling, but goal tackling. I see the thing I want to do, learn how to do it, and then do it well.

My experience playing basketball was . . . different. I went to a tiny school, and when I was a freshman, the girls' basketball coach stuck his head into cheerleading practice to ask if any of us would like to be on the basketball team. If they couldn't find a few more players, they couldn't have a team.

I thought basketball sounded, like, totally fun. I was no Air Bud, but I could be a warm body on the team. The first day was a blast. Basketball was new for most of us. *I like trying new things.* We dribbled, shot, and did whatever else basketball players do. A few of the girls were naturals. The rest of us, not so much. I wasn't worried. I was having fun.

Soon, though, the newness wore off. It was no longer a quirky hoot to attempt a bounce pass. I noticed that while everyone else improved with each day and each drill, I didn't. After a week (and then two weeks), I was just as bad at basketball as I'd been when we started, and a whole lot worse than those who'd started with me.

The coach tried to help me. He was kind, but methods that worked for everyone else failed with me. One day, he said we

could leave practice as soon as we made ten free throws. When I was the only player left in the gym, the coach moved me off the free throw line, closer to the basket. He changed the requirement from ten baskets to three. He moved me closer again, until I was almost directly below the hoop. Finally, he told me if I could make *one* basket, from *anywhere*, I could go home.

I didn't enjoy being terrible at basketball, but I didn't worry about it. I was able to laugh when the coach said to the team (in the middle of a game he had to put me in because everyone else was hurt), "If you have to pass it to Dana, it's okay." I took my basketball photo holding the water bottle. That felt appropriate.

Why bring up basketball in a book about cleaning? I didn't stress over my utter failure. I felt no angst over my inability to figure out something that others seemed to learn effortlessly. Playing basketball wasn't my identity. For most of my life, my failed attempts at "getting organized" didn't freak me out either, because my living space wasn't my identity. I was confident the reason my spaces were disastrous-without-exception was that my focus and energy were spent on other things. One day, when it mattered to me, I was sure I would kick cleaning's butt.

I collected magazine pages and printed internet articles (stored in boxes in the garage or maybe the attic) for the magical day when I'd become a stay-at-home mom and my home would finally be a haven. I planned to create a place of rest and beauty and streamlined efficiency for my family. I'd figure it out just like I had figured out other stuff.

That didn't happen. When I ended up at the point in my life where I thought I'd settle easily into a rhythm of neatness, I felt blindsided by reality. The opposite of a magical transformation happened. Instead of "having nothing to do but clean, cook, and

decorate," my house was worse than ever because I was in it all day long with babies who made my previous strategy of marathon catch-up sessions impossible. I was bewildered. I'd never liked my messy spaces, but I'd always assumed they wouldn't be messy once I cared enough. I finally cared enough, but caring enough wasn't enough.

I grew a little panicked, and then a lot panicked, because I could no longer deny something was wrong. The thing that seemed so simple for everyone else was impossible for me. I'd do a little better for a little while, fail, and then come up with a new way to try. Every time another of my super logical, totally-should-work plans failed, I lost a little more hope. I'd always wanted to be a mom, and I was living my life's dream, but attached to the identity of being a mom was a home. Right or wrong, the state of my home felt like my job review or my report card, and I was failing.

The Extra Layers of the Struggle for Women

I write for women not because I'm under the delusion that men don't struggle the way I did, and not because I think it's a woman's job to keep the dishes done and the clothes clean; I speak to women because I speak from my own experience, and I'm a woman.

As a woman, I understand that, right or wrong, brought about by creative design or social constructs, many of us who feel bewildered and inept at keeping our homes from being total disasters feel like there's something wrong with us *as women*. There's an assumption that women should be able to create

comfortable homes. We think we're supposed to have the "woman's touch" that a bachelor pad lacks.

In social situations, it's usually women who default to talking about cleaning the way farmers default to talking about the weather.

"I just can't understand how anyone can sleep knowing there are dirty dishes sitting in the sink."

"How in the world does he not see that his socks landed on the floor when the laundry hamper is, like, *literally* eighteen inches away?!?!"

"Who does that? Who just takes off their shoes in the middle of the room, trips over them an hour later, *doesn't* pick them up and put them away, and then trips over them again? And *still* doesn't put them away? I mean, what is wrong with him?"

It's pretty standard schtick between women. They don't always say it outright, but the underlying message is: He is dumb or clueless or hopeless. Good thing he has a woman around to make up for his stupidity.

But what if you relate more to the man who's being bashed than the woman doing the bashing?

And what if you hear this (which I have): "It's a good thing he brings home a paycheck because I don't even know if I'd need him around otherwise"? Self-worth plummets. I didn't bring home a paycheck when my home and my bewilderment were at their worst. Maybe you bring home a paycheck but you still feel pressure to be naturally good at all things home-related.

When little boys coo to a baby doll or little girls play with toy hammers, we celebrate that they aren't bound by the constructs of gender role expectations. Yet many women who feel competent in all sorts of high-pressure situations can be brought to

tears by their endlessly messy kitchens. The information I share is for men to use as well. A dishwashing routine doesn't care if you can grow a beard. But the emotional component is not to be denied in this particular struggle, and based on my own experience and the heart-wrenching stories that arrive in my email inbox on a daily basis, it's primarily women who let this struggle affect their identity and sense of self-worth. That's why I write (mainly) for women.

My hope and prayer is that what God has shown me through His Word will change you too. (Not change you, like, make you not messy anymore, but change your heart and change how you see yourself.) I pray the words in this book will help you understand who God is and who you are and how much He loves you exactly the way He made you.

Chapter 2

Why It Feels Like Cleanliness Is a Spiritual Issue

C leanliness is next to godliness" is one of a few phrases people love to rattle off as if they are found in the Bible, even though they aren't. "Neither a borrower nor a lender be" is another one of these phrases. The character Polonius said that one in *Hamlet*, but the line sounds like it was pulled straight out of Proverbs. "God helps those who help themselves" is a saying often attributed to Ben Franklin. (That one's definitely *not* in the Bible.)

As I sat down to write the first draft of this chapter, I Googled, "Who said 'cleanliness is next to godliness'?" I hoped the answer was Shakespeare. If the answer was Shakespeare, I could pretty easily dismiss the statement. Unfortunately, it wasn't Shakespeare, and what I learned made my heart sink. I felt the weight of the need for the message of this book even more.

The famous preacher John Wesley is credited with saying

"Cleanliness is next to godliness" in a sermon back in '78. *1778.* Right around the time the USA became a country.

Google provided me the Dictionary.com definition:

Being clean is a sign of spiritual purity or goodness, as in *Don't forget to wash your ears—cleanliness is next to godliness.* This phrase was first recorded in a sermon by John Wesley in 1778, but the idea is ancient, found in Babylonian and Hebrew religious tracts. It is still invoked, often as an admonition to wash or clean up.[1]

Mmmm-kay. *But it's not in the Bible.* I didn't even have to click a link to feel disheartened.

Other websites were listed in the Google search results. Most included phrases like this in their blurbs: "No, the actual phrase is not in the Bible, but the idea is there." According to them, maybe the Bible doesn't *technically* say cleanliness is next to godliness, but it's pretty obvious that, yes, cleanliness is next to godliness.

There is basis for the general idea that cleanliness and godliness are related. God chose to reveal Himself to the world through the Law (the first five books of the Old Testament), and the Law does cover quite a few health issues solved by cleanliness. God created the world. He created our bodies. Dirt and bacteria (which He also created) can be dangerous to our bodies and our health. Cleaning is absolutely necessary. But cleaning is not a spiritual issue.

All the "buts" I saw in answer to my Googling frustrated me. This is what I imagine or assume those articles said: "Well, no. Technically, the Bible doesn't say cleanliness is next to godliness. Not in those exact words, at least. But . . . *it might as well say*

that." Some translations of 1 Corinthians 14:33 refer to God as a God "of order." Those words get thrown around a lot in discussions about the relationship between cleanliness and godliness even though that Scripture passage is talking about how a meeting should be run. (FYI, running meetings efficiently happens to be at the tippy-top of my list of special skills.) There is a lot of talk in the Old Testament about things that are determined to be unclean because they were around something dirty, and the books describe processes to go through to make those things clean again. And then there's the book of Proverbs, the book that shares so many life principles, and a lot of those principles have to do with the reality of dirt.

And of course, Proverbs ends with the Big Mama Chapter of cleaning guilt. I saw multiple mentions of "the Proverbs 31 woman" in the but-but-buts defending the concept of cleanliness being next to godliness, even though the phrase isn't in the Bible. Did you catch that? If someone asks whether cleanliness is next to godliness, a lot of people use the woman described in Proverbs 31 as an answer to that question. So we have to talk about her, right? I decided to tackle this passage head-on as soon as I started working on this book, even though I was nervous about it.

The Picture of the "Perfect" Woman

The woman described in Proverbs 31 is often referenced by Christians as the ultimate woman. She's busy. She's smart. She isn't lazy. The Proverbs 31 woman plans ahead and handles stuff and is generous and works hard, and her husband thinks she's awesome. She does it all, so people just assume she's a neat freak.

Do you know what is never discussed, even one single time, in what people think of as the all-women-should-be-like-this chapter of the Bible? Cleanliness. Cleanliness isn't mentioned in passing or even alluded to by another word like *organized*, *orderly*, *neat*, or *tidy*. There isn't a single reference to how clean the Proverbs 31 woman's house is.

Here are the qualities, in list format, of this amazing model of what a woman should be. I've included my own imperfect interpretations as well.

- She's "of noble character" (verse 10). Unquestionably, she's a good human.
- "Her husband has full confidence in her" (verse 11). Her noble character has been validated by the man who knows her better than anyone else.
- Her husband "lacks nothing of value" (verse 11). He has legit everything he needs in her.
- "She brings him good, not harm" (verse 12). This is a partnership, not a competition.
- "She selects wool and flax" (verse 13). She has an eye for high-quality stuff.
- And she "works [referring to the wool and flax] with eager hands" (verse 13). She loves this kind of stuff!
- "She is like the merchant ships, bringing her food from afar" (verse 14). She's a foodie?
- "She gets up while it is still night" (verse 15). She isn't lazy.
- "She provides food for her family" (verse 15). She makes sure her people have food to eat. Also, note that providing food isn't necessarily the same thing as cooking.
- She also provides "portions for her female servants"

(verse 15). She is a fair and good boss; also . . . don't miss the fact that she has servants.

- "She considers a field and buys it" (verse 16). She's always looking for a good deal, and not just on toothpaste.
- "Out of her earnings she plants a vineyard" (verse 16). She's smart with her money and makes it work for her.
- "She sets about her work vigorously" (verse 17). She throws herself into her projects.
- "Her arms are strong for her tasks" (verse 17). Her projects aren't onetime things; she's always up to something, and the strength she's built is visible. No need to pretend to be weak.
- "She sees that her trading is profitable" (verse 18). She's business-savvy, watching for what is and isn't worth her time.
- "Her lamp does not go out at night" (verse 18). She keeps working on her stuff, even after most people would have headed to bed.
- "In her hand she holds the distaff and grasps the spindle with her fingers" (verse 19). She's doing the work. More work. In addition to all that other work.
- "She opens her arms to the poor and extends her hands to the needy" (verse 20). She's caring and helpful and unselfish.
- "When it snows, she has no fear for her household" (verse 21). This woman is prepared. She has plenty of blankets and coats in the closet.
- "All of them are clothed in scarlet" (verse 21). We're not talking about rags. These are the cozy, soft blankets and nice coats that keep you warm *and* looking good.

- "She makes coverings for her bed" (verse 22). She's a quilter. Why buy a nice blanket when you can make it yourself?
- "She is clothed in fine linen and purple" (verse 22). She has style.
- "Her husband is respected at the city gate, where he takes his seat among the elders of the land" (verse 23). Both of them are awesome at their jobs. No feeling threatened by each other's success in this house.
- "She makes linen garments and sells them" (verse 24). She can help you with your style, too, and she knows what her talent is worth.
- She "supplies the merchants with sashes" (verse 24). This is a significant business venture. She has wholesale deals.
- "She is clothed with strength and dignity" (verse 25). People see her worth and understand it.
- "She can laugh at the days to come" (verse 25). She's prepared. She's got this! Whatever it is.
- "She speaks with wisdom, and faithful instruction is on her tongue" (verse 26). She owns the fact that she has something to share that will help other people.
- "She watches over the affairs of her household" (verse 27). She has a handle on what's going on in her home and in the lives of the people in her home.
- She "does not eat the bread of idleness" (verse 27). She doesn't embrace laziness.
- "Her children arise and call her blessed" (verse 28). The kids get it.
- "Her husband also" (verse 28). Hubby gets it too.
- "And he praises her" (verse 28). He's appreciative of who she is and all she does, and he lets her know it.

- "Many women do noble things, but you surpass them all" (verse 29). That one's in quotes, and since it comes right after "he praises her," we can assume her husband is the one saying that. It's not God saying she's the best. It's her husband. As a husband *should* think his wife is the very best.
- "Charm is deceptive, and beauty is fleeting" (verse 30). Tell me about it!
- "But a woman who fears the Lord is to be praised" (verse 30). This quote isn't from Hubby sharing his perspective. It's just a truth. Fearing the Lord is the one thing that matters most, the thing we should all be looking for in ourselves.
- "Honor her for all that her hands have done, and let her works bring her praise at the city gate" (verse 31). Give this woman some credit, y'all.

I'll say it again: Did you notice what wasn't on the list? *Cleanliness.* There's no "Her house is free of dust, and papers are filed in a timely manner." Not a single mention of her children's feet never sticking to the kitchen floor, or her husband never banging his head on a cabinet door she left open.

So even though more than one of the answer blurbs in my Google search started with "No, 'cleanliness is next to godliness' isn't in the Bible, but . . ." and continued by mentioning this Proverbs 31 woman, the passage has nothing to do with cleanliness. Or lack of clutter. Or color-coded pantries. Even vaguely.

Scripture honors the Proverbs 31 woman's work ethic. Her ingenuity. Her trustworthiness. Her creativity. This woman is a go-getter.

When I think of the qualities listed in Proverbs 31, I think

about specific women I've known in my life. I think about the women who organize and cook huge dinners and plan events for churches or schools. We gladly let them take charge because we have confidence they will do the job well.

I think about female business owners I know. The variety of tasks they manage on a daily basis, as they support their own families and the families of the people who work for them, is awe-inspiring.

I think about all the women who "have a lot going on." They volunteer to run bake sales. They serve as treasurers on the boards of three different organizations. They handle huge professional responsibilities during the workweek and sew blankets for refugees on the weekends. They can turn piles of fabric scraps or paragraphs of words into beautiful things. They pour their hearts and their time into being amazing mothers, supportive wives, and trustworthy friends.

I think of the conversations I've had about clutter with these amazing, capable, responsible, and impressive women who remind me so much of the woman described in Proverbs 31. I've seen their eyes mist over, heard them attempt to catch their breath as they suppressed panic at the mention of cleaning and clutter. These women have so many parallel qualities to the woman described in Proverbs 31, but the state of their homes, along with their assumption that Ms. Proverbs 31 did all that *and* had a perfect home, makes them want to avoid that chapter of the Bible.

It's assumed that a woman who is admirable and worthy of being praised would have a perfect house. But that's not in Proverbs 31. It isn't even implied. So why do we assume her house looks perfect? Why does the idea that cleanliness is next to godliness seem to make so much sense? Why in the world do I need

to go head-to-head against a statement made by John Wesley? I'm a woman in Texas who makes a living by figuring out, writing about, and teaching people how to get their homes under control and break through their death-grip attachments to clutter. I'm no theologian, and I'd prefer not to push back against one of the most well-known theologians of all time.

I need to refute the statement because *the statement is false*. The statement is convenient, though, and its convenience means it gets used often enough for people to forget it isn't actually true. Anything we incorrectly assume about God is dangerous.

Cleanliness has nothing to do with godliness. Rather, "It is by grace you have been saved, through faith—and this is not from yourselves, it is the gift of God—not by works, so that no one can boast" (Ephesians 2:8–9). Nothing we can do achieves godliness. *Nothing.*

We are incapable, on our own, of having anything to do with God. God is holy. We're not. We consistently commit sins like selfishness, pride, and greed. But if we believe "cleanliness is next to godliness," then we start to think that if we could just get our houses clean, we'd be good.

But we're not good. It's impossible for us to be good on our own, and that's why there's grace. Seeing cleanliness as the thing that will get me godliness-adjacent takes my focus off Jesus. *He* is the only one who can get me to godliness.

Blanket of Grace

I can be inspired to clean by reading a description of an ambiguous superwoman in the Old Testament (a description that, again,

never once alludes to cleaning), but if I let that inspiration blur into a belief that cleaning my house, or being busy and productive, is going to bring me closer to God, that isn't inspiration. It's entering the dangerous territory of thinking my efforts can bring me closer to God instead of His grace alone. And if I try yet fail to keep my house out of Disaster Status, and I believe that failure is going to affect my relationship with God, that is equally dangerous territory. Either way, I'm focusing on the wrong thing.

Here's what I do need to focus on: Jesus. The only way to get to God is through Jesus. Period. "Jesus answered, 'I am the way and the truth and the life. No one comes to the Father except through me'" (John 14:6).

Godliness/holiness that lets us have a relationship with God comes only one way: through Jesus' sacrifice and our acceptance of the mercy and grace He gives us. That's it. Saying cleanliness is next to godliness isn't just *not right*; it's wrong. The concept implies we get closer to God by washing behind our ears or by doing the dishes.

Thinking this way is tempting though. Scrubbing bathroom tiles feels easier than accepting and making sense of grace. It isn't, but it's easier to *understand*, to put on a to-do list and cross off with the satisfying glide of your favorite gel pen. Cleaning a toilet feels easier than understanding grace because cleaning a toilet is something you can control. If you can see the difference between a gray ring around the edge of your bathtub and the shiny sparkles after you've scrubbed it away, you know you've done what you set out to do. The results were within your control.

Grace takes a moment to accept but a lifetime to understand and appreciate. There are times when I question whether God cares about me or hears my prayers. In those moments, I would

give anything if scrubbing a grimy bathtub could reassure me that everything was good between me and God. It would be nice if a physical action that took fifteen minutes (forty-five if it has been a while . . .) could be plugged into a spreadsheet to see if all my works added up to holiness. Instead, grace feels harder. Depending on grace means acknowledging there has never been anything I could do to achieve the holiness God gave me through Jesus. My delusions of control must go. Grace doesn't allow for them.

The beauty of grace is that God is ready to give it to anyone who accepts it. Through grace, Jesus' righteousness is placed on me. I think of grace as a blanket of Jesus' holiness that covers all my sin, so when God looks at me, He doesn't see that sin. Instead, He sees Jesus' holiness. But I don't have to dig that blanket of grace out of the back of an overstuffed closet. Even putting on righteousness isn't something I do. Jesus places it on me simply because I place my faith in Him (Romans 3:22). I understand and acknowledge who I am, who He is, that He desperately wants me, and that I desperately need Him.

Scrubbing the bathtub matters. Just don't think it matters in your relationship with Jesus.

We Have to Talk About Laziness

But why, oh why, does cleanliness *feel* like a spiritual issue? Why did I, who fully understood that my only way to be holy was to be made holy by Jesus, pray so hard for God to cure my messiness and then question everything about my spiritual life when He didn't?

I believe there are a few reasons. The organizational and cleaning skills of Lady 31 may not have been mentioned in her list of accomplishments, but we know for an undeniable fact that she was not lazy. She worked very hard.

The general assumption is that messy houses are the result of laziness. *Ouch.* It's assumed so hard and so consistently that I'm going to unpack this concept here for you, because unpacking it was a big part of my own deslobification journey.

I'm not claiming at all, whatsoever, that I don't have moments of laziness. But I learned through my own (trial-and-error) deslobification process that the reason my house was a mess was because I was doing things incorrectly. The work I was doing in my house didn't have the impact it should have had, and that lack of impact left me bewildered.

I can't count the number of times I spent an entire day cleaning and then had to give double-digit hints to my husband when I asked him if he noticed anything different about the house. I was putting forth a lot of effort but had little to show for it. I clearly remember fighting back tears while explaining this exact frustration to my husband. He was trying so hard to be supportive, to take his newly-a-stay-at-home-mama wife seriously, but he couldn't hide that what I was saying didn't make any sense. To him or to me.

"I have been working and working all day long, and the house doesn't look like I've done a thing." I'd washed our clothes, scrubbed the bathtubs, and mopped the kitchen floor, but the kitchen counter was piled high with weeks' worth of mail and the love seat was completely covered with clean clothes waiting to be folded and put away.

I knew I'd been busy all day. I knew our clothes (though

wrinkled) were clean. I knew the bathtubs were ring-free and the kitchen floor was sparkling. But I also knew I'd never convince anyone who saw the inside of my house that I hadn't spent the day doing nothing. And that was bewildering and unbelievably frustrating. Whether or not I had moments of laziness wasn't the issue. The issue was that even when I worked to the point of physical exhaustion, my house continued to look like I hadn't done a thing. That boggled my mind and made all my effort feel pointless.

I saw beauty and possibility in *stuff*. I gathered oodles and gobs of it. I wondered why my house was so hard to keep under control and didn't see the relationship between not being able to handle my home and having too much stuff. The people I hoped would teach me didn't know what I needed to be taught, so I never got anywhere.

My point is that a messy house is not necessarily a result of laziness. For me, it was a result of not knowing which tasks and mindsets needed to be my priority. I continually treated my house in the same way I treated other areas of my life in which I excelled. I treated my house like a project. I'm pretty amazing at projects. I can plan, execute, finish, and evaluate a project better than many. People who watch me do this consider me highly organized. I can plan out meals for a couple or a crowd and make sure everything is served on time. I can anticipate, research, plan, and execute every detail of a family trip. I can direct a theatrical production in which every member of the cast and crew knows exactly where to be and when to be there and what to do while they're there.

Treating my house like a project didn't work. I'd spend a weekend (or a week) doing a whole-house overhaul, promise

myself I'd keep it that way this time, and then a week later experience total despair because the house was back to what it had looked like before the overhaul. Or worse.

This was what made my ineptitude about my home most confusing and so embarrassing. I am an intelligent person. I count on being able to analyze a situation and solve a problem. But my house made me feel dumb. Feeling dumb about my house and knowing I was an intelligent person embarrassed me.

I'll go into more detail in future chapters, but as I've shared my "issues" on the internet, I've learned that this connection between being highly competent in creative and professional pursuits while being bewildered by day-to-day housekeeping is actually very common. And often the result is shame.

A few years ago, I took a survey of my audience and received over fifteen hundred responses. On the question "How much do you identify with Dana's Slob Struggles?"—with 1 being "I don't relate at all" and 5 being "I wonder how she knows exactly what's going on inside my brain/house"—over 92 percent chose 4 or 5. Over 57 percent selected 4 or above to this question: "How surprised are people who know you professionally when they learn your home was/is an embarrassing mess?"

In the same survey, I learned that those who related to my "struggles" included all sorts of successful and intelligent people: surgeons, members of Mensa, university professors, lawyers, CPAs, engineers, multiple *NYT* bestselling authors, therapists, archaeologists, professional musicians, pastors, librarians, military officers, an aerospace computer programmer, a jet engine mechanic, and many more. Lots of people with master's degrees and PhDs.

These are not lazy people. They are driven and successful.

But the fact that the state of their homes would make an outsider assume they are lazy is mind-boggling.

If you relate to a lot of the things that kept Lady 31 busy, allow yourself to consider that you just need to learn. Let go of your bewilderment and know there's hope. The good news is that once I figured out the things I needed to know, I learned I could spend a lot *less* time working on my house and made *more* progress!

Discouraging Encouragement

You might want to put on some steel-toed boots, because I'm probably going to step on a few toes with this one. (I'm stepping on my own toes too.)

I once let my kid have a last-minute slumber party. I had to go through a lot of mental gymnastics to be willing to let that happen. It was a big deal for me to open my home to others without proper warning or enough time to do a major overhaul. I was working on this deslobification thing, and my perspective had shifted. Our home was in much better shape than it had been in the past, and I was accepting how important it was to provide a space where my kids could invite friends over, even when that space didn't look the way I wished it did.

I decided to get over myself and the icky feeling in my stomach and let my son have friends over. It was his ninth birthday, and he'd suddenly decided he wanted to have his party before school started so he and his friends could swim at the local pool. I'd been thinking I had until mid-September to plan the party and clean the house.

The main areas of the house looked decent, and the middle of the floor in his room was clear. I told myself the boys wouldn't really hang out in his room anyway, so I focused my limited time working on the game room where they would sleep.

I was wrong. His bedroom was where everyone wanted to be.

At one point during the party, a child came into the kitchen and told me, "Good parents make their kids clean their rooms." It took a few about five years, but I do like that kid again. Kids are so *adorably* honest, and my biggest fear, my biggest insecurity, was spoken directly to me by a nine-year-old: You're a bad mom.

I explained to this kid that he was being disrespectful. I also know for a fact that his parents would have crawled under a table in shame if they knew he said such a thing. My own child once asked a friend why her laundry room was so messy, even though I'm pretty sure ours was three times worse at the exact moment she said it. I know kids say things. But that child most likely used that phrase because he had heard it before.

I get it. As parents, we're training our kids for life. Part of that training is teaching them to clean. Some parents are better at this than others. Generally, the parents who are better at making sure their kids consistently pick up their rooms are the ones without Slob Vision themselves.

It's not easy for anyone. Parenting, in general. Getting kids to pick up after themselves, specifically. Parents lecture, explain, and justify their requirements and expectations. We say completely logical and true things like, "We need to take care of our home because God gave it to us."

But then we say things like, "Good parents make their kids clean their rooms," and something blurs. Something blurs because if that is true, then it must also be true that parents who

never think about picking toys up off the floor must be bad parents.

I don't think less of a parent who has said that to their kids. I've said some things in the name of "motivation" that don't hold up under closer scrutiny. I regularly pray to God that all the dumb stuff I do and say won't ruin my kids. But this is a reminder to myself to be careful. Those parents may not have said those exact words, or they might not have realized what they were implying. I can say for certain they didn't intend for their kid to repeat them to another mother. This is a reminder to me that my words have consequences. That situation was annoying and a little hurtful, but it wasn't a spiritual one.

A phrase like "cleanliness is next to godliness" sounds so logical, it can come out of a mama's mouth without her ever stopping to consider that it isn't a biblical principle. Some kids can grow up unaffected by the phrase. Their homes, once they have them, will rarely get to the point where they think back on the catchy phrase and question their salvation.

Some kids take the concept of cleanliness being next to godliness to heart, and it feels so right because they love Jesus and they love organizing. They grow up and become passionate about keeping dishes done and toilets sparkly. The phrase feels like an affirmation, like they're heading in the right direction. The house looks good, cleanliness is next to godliness, and if Jesus showed up on their doorstep, they'd be proud to let Him come inside.

But then there are People Like Me who desperately want to open our front doors, but we just can't. We try (and try again) every method that promises to get our houses clean in a day or a week or even a month. We fail (and fail again). People Like Me latch on to the "cleanliness is next to godliness" concept and

we start questioning ourselves and our relationship with God. Because if cleanliness is next to godliness, then the state of my home proves I'm going to hell.

We pray and we beg. We make bargains with God, and we start to wonder why He isn't hearing our prayers. We wonder if maybe we don't love Him as much as we thought. Or maybe *He* doesn't love *us* as much as we thought.

If you're the one who was given encouragement or instruction that backfired by confusing you spiritually, try to focus on any good intentions. If you're the encourager who now worries that you were actually a discourager, you can do better now since you understand better now.

When Culture and Christianity Get All Mixed Up

The most transformative spiritual experience of my teenage years happened while I was on summer staff at a camp. There were cabins in the woods at the edge of a lake, with trails and nature and all those good things. I was away from home for the first significant amount of time in my life, spending twenty-four hours a day with others who had the same purpose of sharing the love of Jesus. I remember those days as some of the happiest of my life.

Despite being right in the middle of the woods, the buildings at that camp were clean. Amazingly clean.

We washed dishes, mopped floors, cleaned bathrooms some weeks, and worked as camp counselors other weeks. We were trained in all things sanitation. The camp took great pride in

passing every health inspector's visit (even unexpected ones) with flying colors. We did things right. Correctly. I learned how food should be stored, why dish towels should definitely not be thrown over your shoulder, and how to properly clean a shower.

These were all things my mother had taught me at some point in my previous sixteen years, but now I was no longer the child. I was a somewhat responsible adultish person, and suddenly, it all mattered to me. Besides, we weren't just cleaning for the health inspector. We were scrubbing toilets for God! Don't just wipe the sinks—make them sparkle!

As I wrote the first draft of this chapter, I realized that first magical summer happened over thirty years ago. I am now the mother of three people who are older than I was then. I am (significantly) older, and I'm (at least a little) more spiritually mature. All the things I learned about cleaning at that camp were true. The twenty-step checklist for cleaning the bathhouses each day (with ten extra steps on Saturday) was excellent. I learned to do a job well, stay committed to it, and follow through. I understood that people were counting on me. These are life skills that have positively impacted me.

And whether I was getting a cabin full of eight-year-old girls to stop talking after lights-out or vacuuming bat poo from the chapel's carpet early in the morning, I was doing it for Jesus.

Now let me tell you about a different camp. This camp I went to as an adult, alongside my own teenagers, not for an entire summer but for a week. This camp was located in a rural area of South America. The organization we were with called it their "jungle camp." The setting was lush and beautiful, and the morning's misty mountain view made my eyes misty too.

Spiritually, I had an amazing week, exponentially multiplied

by the fact that my own children were experiencing something similar to what I had experienced at summer camp back in the '90s. But cleanliness? Well, the standard was different. You might say it was worlds apart. The South American campers washed dishes joyfully but without the luxury of hot water. According to what I'd learned at the North American camp, washing dishes without hot water wasn't even an option. The South American dishwashing routine definitely didn't include soaking the dishes in bleach water between washing and rinsing. Bathrooms? I'll just say my daughter learned a significant life lesson: Technically, you don't need a toilet seat.

Had cleaning methods been the most important issue, each camp might have looked askance at the other, maybe even going full stink eye over how the other one did things.

But the heart of the two places was exactly the same. At both camps, people who loved God came together, passionate about helping others learn the life-changing truth about God's love for them. The message was the same. The heart was the same. They just cleaned differently, and that did not in any way impact the power of God's love being shared or lives being changed.

I knew this. I knew that much of the world rolls its eyes at the germophobia of Americans. I see God's plan in the fact that within a month of realizing I was going to write this book, I was placed smack-dab in the middle of a compare-and-contrast experience that proved this book's whole point. Two ministries. Two different cultures. Two different ways of getting things done. Two different cleanliness standards. Same God.

Chapter 3

What Jesus Actually Said About Cleanliness

*I*n 2019, I read through the Bible. All of it. I knew God was pushing me toward writing this book, and I didn't take the assignment lightly. (Translation: I was scared.) I was supremely unqualified, but God had worked hard in me to change my heart and give me understanding. God had shown me, so clearly, that He had never asked me for a perfect house. He'd asked me for my heart. And it seemed like no one else was saying what I knew My People needed to hear.

But I'd never read the Bible from page one to the end. I'd once heard a Bible teacher I admired say that God convicted her to read every word of the Bible before she got up on a stage to teach about it. I groaned. I didn't *want* to read the Bible from beginning to end. I felt like I'd *probably* read all of it already anyway. I'd been in church every Sunday of my entire life (except for a year or so in college). As an adult, my spiritual life had been completely transformed by daily Bible reading. I knew and

believed there was huge power in reading the Bible. I just didn't want to read the whole thing from beginning to end, because that's not how I like doing things. I like deep dives into single books like 1 Corinthians or Genesis or Acts, reading slowly and carefully and paying attention to the details.

Reading the whole Bible seemed like it would take about sixty-seven years, but I couldn't argue with the fact that if I was going to be all in on God's Word, I needed to read it all. I started in January and aimed to read three pages each day. I'd get a little ahead and a lot behind. In August, when I was up to the Psalms (a *whole* lot behind), I felt compelled to ramp things up and finish so I could start writing this book.

The Psalms were a difficult place to dive in so hard. They're poetry. I pretended to love poetry while I was an angsty teenager, and I can appreciate a rhyming couplet on certain days of the month. I understand that poetry can express human emotions with a freedom that prose lacks. But y'all. Poem after poem in Psalms, focusing on grief and fear and mean people doing mean things? It was *a lot.*

As I plowed through Psalms, I tried to remind myself of the beauty of each psalm on its own, but reading all of them together just about did me in. After Psalms, I enjoyed the hot-and-bothered spiciness of Song of Solomon, but then came Isaiah and the prophets. More poetry and lots of intense, difficult, and confusing prophecy. I ended the Old Testament with some pretty intense malaise. And despair.

Then, in Matthew, Jesus showed up. I got teary. The angst and confusion and depressing poetry of the last chapters of the Old Testament gave way to relief. I felt physical, emotional, and (of course) spiritual relief that Jesus had arrived.

From the first recorded words that Jesus spoke, I felt a sense of "Oh, I get it now." As Jesus referred to what had been written in the Old Testament, I experienced many "Ooooooh, so thaaaat's what that meant" moments. I felt like I'd been slogging through a textbook on my own, trying to figure out what everything meant, but then the teacher finally showed up and explained it all. Scratch that. The *author* showed up.

When I'm confused about something in the Bible, when I find a statement or idea that's hard to understand, I look to whatever Jesus said. If He talked about it, I want to focus on His explanation. Jesus is the end goal of the entire Bible. His plan is the game plan. If He speaks directly on the subject, His words are the ones to focus on.

Truth over Tradition

The Old Testament includes a lot of talk about cleansing and purity, but let's go straight to the source of all wisdom: Jesus. What does Jesus say about cleanliness? I was pretty shocked and excited when I got to the situation described for the first time in Matthew 15. I'd heard the words Jesus had for the Pharisees (a group of powerful religious leaders), but somehow the situation that triggered Jesus to give this blunt lecture had never registered for me before—*even though I thought I'd heard everything in the Bible.* (Score one for Team Read-It-All.) This same story is repeated in the gospels of Mark and Luke, from the perspectives of their human authors.

What situation triggered Jesus to give a speech about harm caused by the religious leaders' focus on traditions instead of

truth? From the account in Mark 7: "The Pharisees and some of the teachers of the law who had come from Jerusalem gathered around Jesus and saw some of his disciples eating food with hands that were defiled, that is, unwashed" (verses 1–2).

The disciples had eaten without washing their hands, and the religious leaders freaked right out: "Why don't your disciples live according to the tradition of the elders instead of eating their food with defiled hands?" (verse 5).

I feel the need to take a moment to clarify that I am a germophobe. I can't start on my chips and salsa until I've washed my hands after touching the menu. Had I been there in this moment and seen a bunch of guys eating without washing their hands, I would have gagged a little.

Washing your hands is a very good thing. But Jesus did not like the religious leaders' question, so He freaked right out back at them. (Not "freaked right out" like losing control, but "freaked right out" like did not cower at their criticism as they likely expected.) He called them "hypocrites" in the first breath of His response to their attempt to shame His friends: "Isaiah was right when he prophesied about you hypocrites; as it is written: 'These people honor me with their lips, but their hearts are far from me. They worship me in vain; their teachings are merely human rules'" (verses 6–7).

As obvious as it was to the religious leaders that people should wash their hands before they eat, it was obvious to Jesus that handwashing should not be considered a spiritual issue. Jesus didn't explain immune systems or compare the risks of malnutrition with the risks of exposure to germs. His goal was not to defend eating with dirty hands. Jesus' issue was with the Pharisees' obsession with traditions. Human rules. Look again at

what He said about them: "'Their hearts are far from me. They worship me in vain; their teachings are merely human rules.' You have let go of the commands of God and are holding on to human traditions" (verses 6–8).

Do you see Jesus' reference to hearts? That's what God has been showing me for years and continues to show me in new and deeper ways, saying, "Dana! I don't care about your messy house. I care about your heart."

Jesus is the master of calling out people's actual motives. The Pharisees' motive was to discredit Jesus and His followers by pointing out that they were eating with unclean hands, going against a tradition they (the religious authorities of that day) taught and followed obsessively. But to be clear, Jesus didn't decide to use Isaiah's words to support a point He wanted to make. Isaiah wrote those words because Jesus would use them in this exact moment. Isaiah, inspired by the Holy Spirit, wrote so that when Jesus quoted his words to the religious leaders in this moment, the people around Him would hear and understand what mattered to God and what didn't. Isaiah wrote what he wrote so this story would be recorded in Matthew, Mark, and Luke (again, inspired by the Holy Spirit) and so you and I could understand too.

That's what makes Isaiah's words prophecy.

God knew all along that the subject of cleanliness would prompt Jesus to clarify some really important stuff about tradition. The same God who included specific procedures about cleaning in specific situations in the Law was planning (all along) to use cleaning as the example of traditions that get confused for sin.

It was always God's plan to make the point that a completely justifiable-on-a-scientific-level freak-out better not be twisted into a spiritual issue. Jesus meant business when He dealt with

this criticism. He wasn't having it. He knew that getting off track about what matters eternally is dangerous, and it had been going on long enough. He was ready to set things straight.

I know every word of the Bible is written for the benefit of every single person who reads it (and for those who never bother to read it), but I feel a special nod when I read the version of this story recorded in Mark. After the Pharisees gasped dramatically in horror as the disciples ate food with their germy man-hands, the author of Mark added a little background info with this parenthetical explanation:

> The Pharisees and all the Jews do not eat unless they give their
> hands a ceremonial washing, holding to the tradition of the
> elders. When they come from the marketplace they do not eat
> unless they wash. And they observe many other traditions,
> such as the washing of cups, pitchers and kettles. (Mark 7:3–4)

Look at this part: "such as the washing of cups, pitchers and kettles." The author of the book of Mark brought up doing the dishes? Hahahahaha! If you've read my first book, you know why I'm still laughing! If you haven't, just know that I said, "Do the dishes!" fifty-two times in that book.

I find it so fascinating that God planned this situation for this particular explanation of the importance of distinguishing between human rules and traditions and the commands of God. God is our Creator. Everything is designed by Him, including germs and dirt and the unfortunate chemical reaction that results in schtanky BO. God designed us to *need* to wash our hands—and other things, like dishes—to prevent illness. But Jesus also makes clear the distinction between human issues and spiritual issues.

The tradition of washing hands got started for a reason. Handwashing feels less like a tradition and more like a basic human reality. But Jesus called washing hands before eating a tradition. And just as it is ridiculous to think that not serving cranberry sauce for Thanksgiving dinner would have spiritual implications, God knows that washing your hands or the dishes has absolutely nothing to do with your relationship with Him.

Cleanliness is a great example of a very good thing that isn't a spiritual issue. Cleanliness is a perfect example *because* it's an easy one to mix up with religion. The point is in the distinction. If we truly believe Jesus is the only way to have a relationship with God, does it matter what we do? Or don't do? It absolutely can't. Jesus is the only way. Not the only way for people who do the right thing, but the only way for any of us. And Jesus being the only way means doing "the right thing" doesn't get us any closer to Him.

Cleanliness doesn't get me an inch, not even a millimeter, closer to godliness or to God. Warping truth is the most effective way to tell a lie. Get just a smidge off the path, and if you keep going that direction, you'll be completely off track after a while. Lost. Mixing up human traditions with the commands of God does that. When the commands of God are studied alongside human traditions without clear distinction between the two, we get off track and lose our way.

A Persistent Misconception

I believe this misconception persists for several reasons. A relationship with God is nuanced. The relationship is nuanced because it's personal, just like my relationships with my own

three young adult children are personal and nuanced. The Bible includes specifics about what God wants from us, but it also grants us a lot of freedom to be different from one another. God has purpose and sees beauty in uniqueness.

Nuance is experienced in personal relationships, and nuance is hard to explain to someone else. So when a person has the noble desire to share the beautiful and life-changing truth of Jesus with others, it may feel easier for that person to give personal examples of growing closer to Jesus as if they are universal steps for growing closer to Jesus.

So even though many a female Christian has genuinely experienced closeness to God as she accepts caring for her home as God's purpose for her in a specific moment, and though she may view cooking dinner as an act of worship because she's providing nourishment for the family God gave her, to prescribe those things as *the way* to get closer to God isn't right. These actions are examples, not a prescription. The joy for that woman comes out of viewing those acts through the lens of her relationship with God and the situation in which He has placed her. It isn't a transaction. We can't exchange doing a load of dishes for a feeling of closeness with the Creator of the universe.

Share your personal examples. But clarify that they're only examples. Be clear that dishwashing is not the thing God is looking for. He's looking for the heart behind the dishwashing. Or the skydiving instructing. Or the contract negotiating.

Doing things for the glory of God doesn't mean doing them to impress Him. Trying to impress God shows you don't know Him at all. Give God glory by understanding who He is and appreciating how He made you, even if how He made you means you have to talk yourself into doing the dishes every

day and don't feel one bit warm, fuzzy, or worshipful while you do them.

The Power Play

Sometimes, perpetuating the misconception/lie that cleanliness is next to godliness is a power play. Extending grace to people can feel risky. Legalism can feel safer and far easier. It's easier to let everyone think they're good with God by checking off tasks from the list. And as a bonus, no one has to worry about living in a messy house.

Of course cleaning matters. Of course washing away germs is important. Of course removing the hoarded excess so your family can live safely matters. But none of this brings you closer to God or keeps Him away from you.

Truth can be scary, and truth is especially scary when you're discussing it with someone who may take advantage of it. I'm a mother of teenagers, so I know this fear well. When my children were little, I saw the value in guarding them from things that were too much for their young minds to process. But as they mature, living their lives away from my watchful eyes more and more, they see and hear and experience things I wish didn't exist. As much as I wish I could deny or ignore these hard things, God has convicted me again and again to dive right in. To have the hard conversations with my kids about the hard things. To discuss the gray areas, discuss what makes them gray, and then discuss them again. And the more I dive right in with God myself, praying for wisdom and reading what the Bible says about things that make me feel uncomfortable, the

more confidence I have in truth and in my ability to trust God completely.

If I teach my kids right from wrong but don't also teach them about God's grace because I fear they'll misinterpret God's grace as permission to sin, I'm not trusting God to show them the nuance. I'm trying to control them. And trying to control someone else means I don't trust God, because I don't trust Him to work directly in their lives.

I understand wanting to stay comfortable. Someone under your authority cleaning the house because they believe God won't accept them if they don't might mean you get to keep living in a clean house. I like being comfortable too, but the more I study God's Word, the more I realize there's very little in Scripture about being comfortable.

Have the long, drawn-out conversation. Talk about cleaning and talk about God. Just don't leave out the distinction between cleaning (a very good thing) and God's grace (the only thing that actually matters). This is discipleship. Discipleship is relationship that points to Jesus and the Bible again and again and again. Relationship is where in-depth discussions happen, where motives and hearts are analyzed, and where the Word of God is referenced and explored.

The Bible is clear about what pleases God and what reflects the holiness He places on you when you accept it. The Bible includes explanations about who God is and what it means to live as His follower. It's all there, and it's clearer than a lot of us want to admit. But if ever there were a clear guidebook that embraces us and allows us to be unique, the Bible is it (1 Corinthians 12:1–20).

If you're confused, look to Jesus. Keep reading the Bible (not

just books about the Bible, like this one). Keep praying and keep asking God to help you understand. If any phrase keeps running through your head, making you worry that God is mad about your messy house, search: "Where in the Bible does it say [fill in the blank]?" If it's in the Bible, find that verse and read the entire chapter, not just that verse alone. Read other chapters around it if you need to, and ask God to show you what He really means by it. He will. You'll experience the joy of understanding that comes as an answer to prayer.

Technically Helping Versus Actually Helping

I really did write this book to make it clear that Jesus doesn't care about your messy house. The title isn't a trick. You won't find a twist at the end where I convince you that a non-messy house is the important thing.

I know you don't need to be convinced. You do not need someone to explain to you that your life would be easier if you could find what you're looking for without causing a crapalanche (a term coined by one of my BFFs, Cliff Bowen). You don't need someone to tell you that you could relax more if your house weren't so messy. You know these things. I call that *cleansplaining*. Cleansplaining is equivalent to mansplaining, which is offensive, unhelpful, and unnecessary by definition. If you cared enough to read this book because your messy house weighs on your mind, you already know everything someone could tell you about why a clean house is a good thing. When someone assumes you need to be told, you feel alienated and disrespected. Attempting to be

helpful but doing it in a way that doesn't help is the opposite of helpful.

Truly helping someone can be kind of an inconvenience. It's much easier (and takes a lot less time and energy) to spout out a few technically true phrases without worrying about whether someone is actually being helped by hearing those phrases. Technical-truth-spouting lets the spouter feel good (maybe even a little heroic) without expending much effort.

As an example, let's talk about wheelchair ramps. Actually, let's talk about one particular wheelchair ramp that made my nostrils flare in irritation. I know a thing or two about maneuvering wheelchairs. I spent seven years dealing with them when my mother-in-law was in poor health. A wheelchair ramp is the perfect example of something that is supposed to be helpful. *Surely* no one would want to keep a person in a wheelchair from entering a building. *Surely* anyone with a heart would want to help. *Surely* adding a wheelchair ramp is always a good thing.

I'm sure this particular ramp was installed long after the building was built. And I understand that angling a wheelchair ramp within limited space isn't easy or cheap. But I also understand that while the person who built this ramp *technically* did what they had to do, they didn't worry about what the person they were "helping" actually needed. They didn't care about making it easy for someone in a wheelchair to get into their building.

To get to this particular wheelchair ramp, you'd have to maneuver the wheelchair between two parking blocks (the things that stop you from running into the curb or the building). Those blocks had been shoved apart, at a wonky angle, *juuuust* far enough for a wheelchair to get through. Barely. Technically. *Probably.*

But the person who measured the space clearly hadn't pushed many (or any) wheelchairs. Y'know what's not easy about using a wheelchair? Getting through tight spaces. I had a hard enough time with spaces that were *clearly* wide enough but had walls or curbs nearby. So that tiny space that was only *technically* big enough (even though it didn't look big enough) for a wheelchair to get through made me mad. I pictured myself bumping into the parking block and injuring my mother-in-law's foot or causing pain in her already weak bones because what was supposed to help was decidedly unhelpful.

Here's the cleaning-related point. When someone who doesn't know how squalor happens sees someone else living in squalor, they often feel the need to help. But having "no idea how anyone could live like that," they can only base their understanding on their own situation. They use their own experience, ability to focus, and energy levels as a guide. They might say something like, "Just do a little every day!" Or, "You just have to make up your mind and plow through!" Or (and this one is the hands-down most annoying phrase to People Like Me), "A place for everything and everything in its place!" While those phrases are technically true, they don't account for the struggling person's actual challenges.

Very likely, just like the wheelchair-ramp maker, the advice-giver is using math. If a wheelchair is twenty-six inches wide, twenty-seven inches is technically enough space for the wheelchair to get through. If a mom-to-be gets rid of all the extra stuff in that guestroom-turned-storage-room, there will be plenty of space for the new baby.

Technically, these things are true. But the math doesn't always work when you factor in real-life variables. The person in

the wheelchair may not be as skilled as the wheelchair athletes shown in YouTube videos. The extra-emotional pregnant woman staring at a room filled with plastic tubs feels paralyzed. She can't even start because she knows she'll face painful memories inside those containers.

The helper spouting off mathematical solutions to organizational or disability challenges possibly has a heart in the right place. (I couldn't bring myself to say *probably*.) But this kind of general advice isn't helpful to People Like Me. Even if the advice is, technically, true.

About … About … About … About … About

I often find myself thinking *about … about … about … about … about* when I hear people giving advice that isn't helpful. It's very easy to talk *about* situations or challenges, to deal in *should*s and *just*s. Advice like that is great for internet clickbait. But for people who truly struggle, speaking in generalities isn't helpful.

We've all clicked on a link that says something like, "Does your clutter make you hate your house?" only to find the "advice" is something like, "Clearing out your clutter will help you enjoy your home more." Or the headline, "Do You Hate Cooking in Your Messy Kitchen?" delivers this "helpful" tip: "It's easier and more fun to cook in a tidy kitchen!" *Duh!*

But *how* do you actually make it happen? What if you've tried to do what you thought people with tidy kitchens were doing, but your kitchen never improved? People Like Me risk eye injuries from rolling them so hard at quick tips that are supposed to fix our lifelong struggles in a single sentence. But we

can't sass back, because the state of our homes makes it look like we *don't* understand these obnoxiously obvious things. At my speaking events, I start by reassuring the audience that I am not there to convince anyone they have clutter. If someone shows up at an event with the word *decluttering* in the title, she knows she has clutter. My purpose is to teach my audience exactly how to get that clutter out of their house, whatever unique challenges they're facing. I see visible expressions of relief every time I say this. Often, I see tears.

I know that people who talk about why being organized is great have every intention of helping. They want to convince others that life is better without clutter. They rattle off the results of scientific studies about how much calmer people are when their spaces are clutter-free. I know there are some whose homes are *mostly* under control who will get the inspirational push they need from that kind of data. I am not one of those people, and I don't write for those people.

I write for the woman who totally gets *why* but has no idea *how*. I write for the woman whose mess can't even be imagined by the person who thinks an inspiring phrase is enough to change a home. I write for the woman whose husband tells her he's not sure he can continue living in their messy house. I write for the parent who always dreamed of leading a scout troop but never volunteered out of fear that the meetings would have to be held in her home. I write for the woman who desperately wants to host a book club but can't imagine letting the people she wants to befriend come past her front door.

As someone who was already desperate to change my home, having my intelligence insulted with an explanation of *why* I should want to change my home meant I stopped listening. I shut

down. I wrote off the speaker or writer as yet another person who couldn't understand my starting point. I felt misunderstood, unaccepted, and very, very alone.

A YouTube video I put out in 2023 surprised me by doing exceptionally well. I should have expected its success though. I filmed it after spending four days at an Airbnb working on this book, and I was tired. In the video, I have unwashed hair and I'm wearing wrinkled clothes. (Those videos always do better than the planned ones where my hair looks great.) It was my first video to get more than a hundred thousand views in its first week. The good and bad thing about online content "doing exceptionally well" is that it reaches people who've never heard of you. In my case, that meant people who had no idea about my unique angle on this housekeeping stuff.

In this video, I was teaching my Layers of a Clean House concept, which is basically my realization that what I had always thought of as cleaning my house *wasn't*. I had counted catching up on daily stuff (doing the dishes, putting shoes away, clearing off counters, taking out trash) and decluttering ("stuff shifting" the clutter from one room to another) all as cleaning. This made the idea of "cleaning my house" daunting because I rarely ever got to the scrubbing or mopping. I spent all my energy catching up on daily stuff and moving clutter out of the way. The video did well because it's a life-changing concept for people like me who've always wondered why "cleaning" doesn't seem to be such a big deal to other people.

Most people who watched the video loved it, but a few hated it. That's fine. I delete comments that shame or discourage people who struggle. One comment I deleted was posted after the video had more than six hundred comments that were 98 percent

positive, saying some version of, "Oh, my word, I can't believe I didn't understand this before, and this changes everything. Thank you so much for sharing this."

The negative commenter was furious. Strangely furious. She used lots of caps and exclamation points and question marks, asking why in the world I was even saying all this unbelievably obvious stuff. She made the definitive statement that "Everyone knows picking up the daily stuff that gets out of place isn't cleaning."

Even though there were more than six hundred comments to the contrary. *Hundreds* of people didn't know that picking up the daily stuff isn't part of the cleaning layer.

"Meet Their Needs"

I've struggled a lot with the idea that this particular message of hope for your home is the one God has given me as a way to minister to women. (And men, but primarily women.) In the beginning, I struggled because it didn't make any sense. Why in the world would anyone want to listen to *me* about anything whatsoever to do with cleaning or organizing? The constancy of my own struggle felt disqualifying. Yet as time went on and I was told, on a daily basis, that sharing my journey was helping others, I couldn't deny I had something of value to share.

Still, I struggled with truly accepting that *this* was the message *God* wanted me to share. He wanted me to write about the super unglamorous and unexciting subject of *cleaning*? *This* was the ministry He had planned when He planted the desire to write in my soul? The quirks and sometimes-frustrating weirdness

God had designed in my brain were always meant to be the basis of my life's work? Mostly, though, I had a hard time grasping that God's plan for me was to teach about the very thing He'd clearly shown me was not a spiritual issue.

While I wrote my first two books about how to go from overwhelmed and frustrated in your home to being confident and capable (though not without struggling) in caring for it, and about my progress-and-only-progress decluttering method, I prayed. A lot. As the books took shape, I felt God answering my prayer: *Meet their needs.*

I knew those needs. I knew exactly what it meant to meet them. I had needed someone to explain to me what most of the people teaching this stuff hadn't known needed to be explained to a lot of us. I needed to hear I wasn't the only person who struggled the way I did. I needed to know that getting my home under control was possible, that I wasn't crazy, and that there was hope. I needed to know exactly *what to do* to change my home and how to get over my hang-ups so I could actually do it. I made it my goal to help my readers meet their nonspiritual goals of improving their homes.

Still, writing those books was a spiritual exercise for me—in the helping, in serving the people who were desperate for help. Needs serve the purpose of showing us our inability to be perfect, our inability to be self-sufficient. They drive us to discover the love of God. Jesus met people's needs, and that's why they followed Him. He healed. He acknowledged physical and mental and spiritual needs, and He met them with miracles. I'm not Jesus, and I can't perform miracles, but I do strive to follow His example. There is spiritual purpose in having nonspiritual needs.

Jesus actually helped people. He saw and named and met

people's physical needs. Because of His legitimate help, people's eyes were opened to the spiritual changes He offered. I read in Matthew, Mark, Luke, and John about what Jesus' ministry looked like while He lived here on earth. There was purpose in every move He made. Jesus helped the people who crossed His path better understand God. By His actions and reactions as God incarnate, He brought all of the Old Testament book knowledge of holiness into real-world, flesh-and-blood experience. He made holiness real for the people who saw it unfold in real time and for those of us who study the written words of those who saw it.

What do I learn (and what can we all learn) from Jesus' example? He didn't lecture or ask for verbal commitments to His cause before He met someone's needs. He healed. He cured blindness and muteness and lameness and paralysis and "female problems" that are still embarrassing for some of us to talk about two thousand years later. Because He healed, people followed. Crowds gathered. They felt seen. They felt hopeful. They felt acknowledged, understood, and far from alone.

My job, as I follow Jesus' example, is to let those who feel hopeless in their homes know they are seen. My ultimate job, though, is to share real hope, and the only real hope that covers all is Jesus, so I need to share about Him too. That's why I needed to write this book. Not as a bait and switch but as a fulfillment of the relationship I started with you—and others—when we some-how collided over the subject of messiness.

Not that there's any expectation of all this leading someone to Jesus. I'm just making the introduction. Whether y'all hit it off is your business. In the Bible, Jesus didn't do any take-backsies on the life changes He handed out when someone rejected Him. The physical healing had value, whether or not the healed person

ended up experiencing the fullness of what Jesus offered. My life work of sharing this message, modeled after how Jesus shared His message, is my own small part of sharing Jesus' love with others who desperately need His love.

Being Understood Feels Like Love

To be legitimately helpful, the helper must understand the legitimacy of the problem. The most hurtful thing that is regularly (and casually) said about those of us who struggle to keep our homes out of total chaos is some version of this: "Well, I guess she just likes living that way." Or, "I guess she just doesn't care." (That one is the most hurtful.) We care. We don't like living this way. We don't like our houses "looking like that," and making those assumptions is the opposite of helpful.

I've learned that feeling understood is the first step to real change. Through more than a decade of leading a community of women who relate to my struggles, I've heard again and again that the most hurtful thing someone can assume is that we don't care. Caring is not the problem. We're always looking for days or weekends with "nothing else to do" but dig our way out of the mess, because we absolutely *do* care.

We were just going about it wrong. I won't go into exactly what we were doing wrong or how to do it right, because that's what my first two books were about: 120,000 words on how to keep house in a way that works for the person who has never successfully done it before. Almost every day, I hear from women who say, "I needed someone who thinks the way I think to explain it to me."

Technically Helping Versus Actually Helping

You may have said or thought that messy people "must just like living that way." It's okay. I've said dumb stuff too. I've made incorrect assumptions. I'm glad you're reading this book. Even if you thought that as recently as the start of this chapter, I'm glad you're willing to at least find out more for the sake of the people you've never quite understood.

The nicest thing my husband ever said to me was, "There's something actually wrong with you." Before you think badly of him, let me share the context and why it made me want to jump his bones.

Every(ish) June 26 for the past twentysomething years, my husband and I have written in a special journal. Back when we got married, we were both teachers, and on our first anniversary, we had the summer off and an entire day to do nothing but celebrate. We went on a bike ride and out to eat, and then we went to the spot where we'd gotten engaged. I brought one of those write-in-able books and, with newlywed energy, declared that on every anniversary for the rest of our lives, we would write memories in this book.

We made up some categories we still use today: places we'd traveled that year, current running jokes (which we don't always remember a few years later), good things, hard things, and more. The first list we always make is things we've learned about each other over the year.

On our first anniversary, making a list in this category was a blast. We laughed and laughed and could barely write fast enough as we thought of all the things we'd learned over the previous year: "He has to have a real breakfast. Eggs and oatmeal or something else cooked on the stove." Or, "She only looks at the ads in the newspaper." After about five years, it became a

challenge to think of new things, but that meant we had moved from quirky observations to deeper, more profound discoveries about each other.

When we'd been married for more than a decade, after I'd been blogging my deslobification process for a few years, my husband was searching for something to put on his list. He said, "Please don't take this the wrong way, but I've learned that when it comes to keeping the house under control, it's like there really is something wrong with you."

I knew exactly what he meant, and I took it as a huge compliment. He'd realized I really did want to keep the house clean. The disaster state we had lived in for so long wasn't because I didn't care, but because there was something about my brain that made keeping the house under control harder for me than for others— like, say, his mother. He had realized I really was trying, but there was a disconnect. I'd never felt so understood in my life.

He said that even though it does drive him bananas when I leave cabinet doors open, he now knows I don't do it on purpose. He understands now that a room with random stuff spread all over it is not in that state because I made a decision to not care about it but because I got caught up in something else and honestly didn't notice it getting that way. Understanding all this helped him love me more and not get (as) frustrated with me.

To be clear, this was the moment when he verbalized his understanding. I attribute much of my ability to experiment in my home to my husband's loving acceptance of me just as I am. His support gave me the freedom to figure things out through trial and error. My very favorite emails come from people who tell me they finally understand their spouse after reading my

words and that their new understanding has improved their relationship. If you're not sure how to best support the messy person in your life, start by understanding them.

Being understood feels like being loved. True understanding of my heart, my emotions, my struggles, and my motivations feels better, I believe, than being put on a pedestal where I worry I might fall at any moment.

Being Understood Is a Rare Gift

Even though it's usually a happy lovefest in my online community of people who understand one another and who wrestle with the same issues, reality smacks us all in the face at some point. We hear snide comments from people who live in or visit our homes. We have to let a repairperson into our home to fix a busted pipe after a week when life was bananas and we got behind again. The frustration comes flooding back.

Not to sound too cliché, but Jesus gets it. He completely understands how it feels to be misunderstood. He was misunderstood when He spoke face-to-face with humans here on earth. Even those who spent every day with Him couldn't wrap their minds around what He was very clearly saying. And the Bible is the most misunderstood and misused book of all time.

Having authored several books, I have a teeny-tiny inkling of what it's like to have your words twisted and taken out of context. In the beginning, when the only people reading your words already know you, everything is fine. As your message spreads (as, of course, you hope it will), people with zero context and heaps of assumptions start reading your words. I know the

frustration of someone taking a single sentence out of my book and acting like that's all I wrote. No matter the sentence, there's so much more to the message than that single sentence.

This happens constantly with the Bible. Y'all, there are some really disturbing things in the Bible—some super depressing parts, some extremely upsetting parts, and some incredibly confusing parts. It makes total sense that someone would read a sentence or section at random and be completely turned off.

The hope is in the whole. The hope is in understanding who God is and seeing His realistic understanding of the world He created and all that has happened in it. The Bible is not a book of pithy sayings to inspire you toward a better life. It's a story of human beginnings and choices (so many bad choices) and of God's plan to redeem us from all of that to bring us into a personal relationship through His Son, Jesus.

The creative process of writing books has helped me understand God more. Sharing my heart through words I know will be misinterpreted and misused is worth it because there are people who need those words. They desperately need to hear the good, the bad, the ugly, and how all those things work together.

I know some of you are reading this book because we're friends. I haven't met most of you in person, but you feel like we have a relationship. We do. I know some of you don't believe a word I've said about God loving you or being kind or generous or even that He is more than a fairy tale. But you've kept reading because you know me and you trust me, even though this all feels like crazy talk to you. You know my heart because of the hours we've spent together through my podcasts or videos or books. You know my heart isn't one of deceit or of trying to convince

you of some falsehood. You may have felt confused or skeptical at some points, but you trust me. So you've kept reading.

That's how I read the Bible. I'm past the skeptical part. I trust the One who wrote it, even when I don't understand all of it. But I had to get to that point. I now feel comfortable asking about the parts I don't comprehend, questioning when something feels wrong, and asking God for understanding. Understanding isn't something I achieve. Understanding is something given to me by God through the Holy Spirit. The more I feel weak, the more opportunity I have to ask God for help understanding. He delights in answering that prayer. *Dee-lights!*

Being misunderstood is not the least bit fun, but sometimes the risk of being misunderstood is necessary in order to share the truth someone so desperately needs to hear. It would have been easier for me to write about teaching theatre arts to gangly middle schoolers (which I've done) or saving money on groceries (which I've also done). I don't mean it would be less work, but it would be easier for me to talk about those things without wanting to run and hide in my closet some days.

But if I didn't share truth, if I only said we should sweep the floors without exploring the reasons behind why such things are legitimately hard for a lot of us, I wouldn't be able to help the people I actually need to help. I wouldn't meet the needs of the people God has asked me to help.

It would be so nice for God if He could have just talked about His love and how He wants us to all be together for eternity. But that would leave out the reality of the thing that keeps us from being together: sin. Grace is a beautiful thing, but it exists because we need it. Without the reality of sin, there's no need for grace.

In a nutshell, here's how it works: God is holy. He is free of sin of any kind. Like, He's sin-repellent. Sin can't even be in God's presence because holy is what He is. It's not something He's worked toward (how I think of perfection) or has to strive for, but holiness is His identity.

He created humans for relationship with Him. He designed us with all the layers of personality, quirkiness, and challenges that are worth embracing in any satisfying relationship. But sin happened. God allowed sin to happen because He created us to have full identities of our own, and part of that is letting us make our own decisions. He could have skipped the free will part, but He didn't—because if a relationship is real, we're in it because we choose to be.

Through personal choices, the first created man and woman sinned. Sin put a wedge in their relationships with God because of the whole holiness thing. God can't have sin in His presence. So God planned a way to restore our relationship with Him, not by ignoring our sin but by making us holy. Holiness and life are intertwined. God is eternal, and God is holy, so those things must go together. Sin brings death. Those things must go together too.

God sent Jesus, His Son, who is also God, to deal with sin for all of us, so Jesus died. In His death, Jesus took the punishment for sin. That punishment wasn't something that could be ignored if we wanted a restored relationship with God, if we wanted life. Jesus defeated sin through His death and defeated death by living again. He wants to give us that life as well, not as a benevolent benefactor but because of His intense desire for a personal relationship with each and every human. Me. You. Every single one of us.

The Weirdness of Being a Christian in the Self-Help Genre

Pastors ranting about self-help books from their pulpits is a pretty standard schtick. I get why. The general spiel is that people shouldn't look to self-help books to fix their problems when really, only God can help them. Only God can truly heal, and only God can provide lasting and all-encompassing hope. Self-help as an ambiguous concept feels a whole lot like self-sufficiency (the tendency to depend on oneself instead of God and the desire to be the one in control). *That's* a sin that rears its ugly head in my life again and again.

Self-sufficiency? Bad. Self-help? Not necessarily bad. I wish the books I write weren't labeled as the very thing some pastors seem to dislike, but self-help describes exactly what they are. Jesus is not going to do your dishes for you (even though He totally could), so it's possible you need a little advice from the self-help section of the bookstore. But the disdain for self-help expressed by some spiritual leaders can make us feel scared to look for help in that section of the bookstore. We fear it's wrong somehow to take advice from anything but the Bible.

As an author, hearing another warning about the dangers of self-help books coming from a pulpit can make me question whether it's okay to offer the help I'm capable of giving. *That* is a problem. An overthinking problem, for sure, but a problem. God never intended any of us to live without relationships with other humans. His plan wasn't for us to tell others He loves them and then walk away, leaving people to figure out life on their own. We're designed for relationships. God made the second human (Eve) because it wasn't good for Adam to be alone. He created

us to need relationships with each other so we can understand our need for a relationship with Him. In the book of Titus, older women are specifically instructed to teach younger women. We're told to care for immigrants, encourage one another, help one another, and so much more.

I firmly believe (and am willing to argue, even with a pastor) that having the ability to meet a need and then *not meeting it* is sin. I therefore believe it is a sin to tell someone to just trust Jesus more, to read her Bible more, when she has shared that she is genuinely hurting and questioning her relationship with Jesus because of her inability to keep her house clean.

My goal in my work is to meet needs like Jesus met people's needs. He fed people. He healed them. He saw and acknowledged and fixed the thing they couldn't see beyond because it consumed their thoughts and caused them to feel hopeless.

In the last chapter, we talked about exactly what Jesus said about cleanliness. In response to the religious leaders making things that weren't spiritual issues into spiritual issues, Jesus said, "You experts in the law, woe to you, because you load people down with burdens they can hardly carry, and you yourselves will not lift one finger to help them" (Luke 11:46). Let's commit to being *actually* helpful. Let's stop, see the pain, understand the problem, and help to solve it. None of that is quick or easy or painless, but legitimately helping while clearly sharing the love of Jesus is always worth the effort.

Magic Versus Miracles

I've been messy my entire life. From a childhood bedroom with toys covering the floor, to a high school locker that exploded with paper every time I opened the latch, to not letting people inside the apartment where I lived alone, every space I called my own ~~eventually~~ quickly became a disaster zone.

Despite my history, I felt blindsided by my messy home when I got married. I had always assumed that once having a lovely space finally mattered to me, I would make it nice. Caring would be enough.

Caring wasn't enough. I didn't experience total despair, though, until after my first child was born. That was when I started to fear something was legitimately wrong with me. I had reached what felt at the time like my final destination. I was a stay-at-home mom. *Now* and *never* were the only options for changing my messy ways. I attempted now and got never.

I remember looking at my four-month-old son's messy room and realizing I hadn't been cured by my new phase of life. I'd been waiting for something to shift in my schedule, my mindset, or my world and make everything fall into place. *And then stay in that place.*

I had been waiting for magic to happen, but it hadn't. The kitchen was always a mess, every flat surface was piled with random stuff, and I was rarely confident that I would find clean underwear in my drawer when I opened it.

I tried so hard. I read books and made notecards and checklists and asked people with nondisastrous houses how they did it. And I prayed. Sometimes, I prayed consistently for days on end. Sometimes, I knelt by the side of my bed for as long as my knees could take it. Sometimes, I cried out to God in moments of desperation.

I wanted to be different from the way I was. I wanted to not be bumfuzzled over this thing that seemed to be easy for so many women in the world. I wanted to solve this problem like I'd solved other problems in my life. But my default setting seemed to be a home that was too messy to let anyone else see.

The heart of my prayer was for God to change me. I wanted Him to cure me, to transform me into a neat and orderly person. When I continued to struggle, I wondered if He was listening.

Every prayer I prayed had value, but looking back with some experience and a little wisdom, I think I once believed prayer was a last-ditch effort at control. I was using prayer as the thing I could "do" when it felt like nothing else was working. But when I look at examples of prayer in the Bible, I see that's not how prayer is supposed to work.

A Desperate Mother

The biblical story of Hannah is one that stands out to me. Her prayer inspires me, but it also scares me. She prayed out of

complete desperation for God to give her a child. Infertility is high on the list of experiences in knowing what it's like to have no control over getting what you desperately want.

Hannah's story is found in the first two chapters of 1 Samuel. For years, Hannah desperately wanted a child. She poured out her heart with such intensity in the temple that she made the priest very uncomfortable. She promised God that if He gave her a child, she would give that child back to Him to serve in the tabernacle. As a *child*. She didn't promise to give the child to God on an ambiguous "someday," but as soon as the child was no longer breastfeeding.

I wonder what my heart would have been scheming with that prayer. When a situation seems completely hopeless to me, a promise made feels like a promise I won't have to keep. I can see myself making such a huge promise in a moment of desperation, but I can also see myself not really meaning it. When I read this story, I catch myself thinking, *Surely God would have understood if Hannah had gone back on her promise to give her child back to Him.* Because I think that, I have to be honest and confess that when I pray, I'm usually not praying the way she did.

I like control. I seek control. But if praying is my attempt at control, am I really praying? Is my goal for God to move so I can snatch back control? True prayer isn't a form of control. It's not an attempt to get what I want by bringing God over to my side. True prayer is giving a request over completely to God and trusting Him to do as He pleases. True prayer is believing God sees and knows what is best.

When I look back at my years of desperate cries for God to change me, I realize I was asking for magic. I was looking for an instantaneous alteration of my brain. I wanted to wake up and

be . . . organized. I felt like God wasn't answering my prayer, but He was. He was just doing a miracle instead of magic. Magic, which is also an illusion, makes people say, "Wow, how'd you do that?"

Miracles, on the other hand, glorify God. They are demonstrations of who God is and what He's capable of, and their purpose is to help us know Him. Sometimes miracles are instantaneous. Jesus gave sight to people who had never been able to see, healed the bodies of people who had never walked. Traveling the world, I've seen people whose legs are shriveled and twisted from years of not being used. When I think of Jesus telling someone who had never taken a step to get up and walk, I imagine the shock on the faces of those who were watching. Contorted, tangled legs straightened out, and suddenly the person had the strength to stand, walk, jump! Instantaneously! In these moments, the glory went straight and unquestionably to God. The purpose of every miracle was to reveal God's power and love to those who experienced or witnessed the miracle.

But there are also slow miracles that don't look like magic at all. They're miracles because they are equally clear in demonstrating God's love and power. God answered my prayer, and He gave me a miracle, but it looked nothing like I thought it would. And it was definitely *not* instantaneous.

My Slow Miracle

One Sunday morning in 2009, God started my miracle. I had wanted to start a blog since I figured out what they were in 2008. I'd always wanted to be a writer, and finding an easily accessible

way to start writing felt like being hit by a lightning bolt. But I didn't start my blog for a year and a half after the lightning bolt hit. My biggest weakness (a house in complete disorder) stopped me from starting on my dream. I knew that new creative projects consumed me, and I didn't feel like I could start this project until I figured out how to not be so disastrously messy. I also wanted to encourage other women, but I felt like I'd have to hide the dirty little secret of my home and live in fear of being found out.

For that year and a half, I tried harder than ever before to get my house under control. I had the new motivation of wanting to start writing, and I still couldn't do it. I experienced more self-loathing and frustration than ever before. What in the world was wrong with me?

That August morning in 2009, I was sitting in church thinking about how the next day could have been the perfect day to start blogging. My second of three kids would go to his first day of kindergarten, and I would no longer have to coordinate naptimes. When my three-year-old daughter took her nap, I could write. For, like, an hour or two. Every day. Because it made logical sense for me to start my blog the next day, I was mad. I *couldn't* start, because the same problem that had stopped me for the last year and a half was still unsolved. I was mad that God hadn't answered my prayer. I'd begged Him to cure me, but He hadn't.

I'd made God an offer, and I couldn't understand why He'd refused it. I wanted to share the things God had been kind enough to teach me. I couldn't understand why He didn't seem to want my gifts of teaching and writing. I felt like He wasn't holding up His end of the bargain I was pitching to Him in my prayers. He hadn't removed my messiness issue, so it felt like He must not want me to do this thing.

As I sat there in church (not listening to the preacher), I stopped my bargaining and started being honest with God. I told Him how frustrated I was over His lack of response to my prayer. I asked Him why He hadn't answered me.

He finally answered, but it wasn't the answer I'd thought I would hear. There was no, "Fine, then. You're organized now. Go ahead and serve Me already." Instead I heard, "Write about that."

What was that?

"Write about your messy house."

Oh. I did *not* want to write about *that*. It had never occurred to me that writing about my deep, dark messiness secret was even an option. I'd been hiding it my whole life, and I was sure no one would want to hear about my messy house. I'd experienced judgment and verbal assaults after accidentally revealing a tiny glimpse of the mess I was hiding. I once left a preschool moms' group meeting in tears after another mother was horrified when I admitted my kids didn't always take their dirty dishes to the sink after dinner because I rarely remembered to take my own. She berated me, talking on and on about how I was failing my children, for long enough that someone else at the table finally stopped her. I sobbed the whole way home. Talking about my messiness in anything other than vague or jokey terms had never occurred to me.

But God said, "Write about that."

In answer to "*Why* haven't You cured me of my messiness so I can do this thing I know in my heart You have called me to do?"

Right then, the name of my blog came to me: *A Slob Comes Clean*. I didn't like the name. I'd never called myself a slob. I'd actually said, out loud, many times, that I wasn't a slob. I was

a germophobe, I didn't like things dirty, I knew how to clean (remember my camp experience?), and I most definitely didn't lie on the couch watching TV all day.

Yet my house was a disaster, and it *was* a catchy title.

Ideas started working themselves out inside my head. This could be a practice blog. I could start doing the thing I so desperately wanted to do. It would be a way to stay focused and figure out how to get my home under control. I'd finally solve the problem that had plagued me all my life, and then I could start my *real* blog with some writing experience under my belt.

This is a really good idea, God.

I didn't announce my plan to the congregation as soon as the service ended. I kept this idea a secret between God and me. I went home and set up a new email address under a fake name. I did everything I could think of to make sure this embarrassing practice blog would *never* be traced back to me. I didn't even tell my husband what I was doing. I called myself *Nony Blanco*. *Nony* is short for anonymous, and *Blanco* is Spanish for my last name, White.

As I write this book, it's been more than a decade since that August day when my now twenty-year-old son started kindergarten and I started my "practice blog." That period was one big miracle in my life. One slow, powerful miracle that helped me understand and know God, His personality, and His plan better than I'd ever known before. This decade-long miracle revealed to me—and continues to reveal to me—how God's heart works and what He wants from me.

God taught me many truths through this miracle. He taught me that He has no interest in or patience for pretending. Pretending is pointless. God sees what I'm doing and why

I'm doing it. Only when I stop trying to hide and stop making excuses can we really get down to work.

He taught me that He welcomes conversations about anything and everything I want to ask Him. He'll answer every question asked by a heart that sincerely wants to hear His answer, but I don't get to choose the answer.

He taught me that He had a plan all along. I was just too busy trying to make my own plan happen to stop and ask God if He might have a different one.

He taught me that He is patient. He let me discover for myself that my way wasn't going to work before He shared His plan with me. God was patient with me when I still didn't grasp that figuring it out *publicly* was the actual plan He had for me. Coming to the end of my own abilities, acknowledging that I'm incapable on my own, and accepting my legitimate weakness and struggle were all part of His plan and His miracle.

God created me for exactly this purpose. He made me to write this book. He designed me for this not-anonymous-after-all career built on the very thing that makes me feel inept. God gave me my unexplainable inner drive to tackle problems and to create things. But with that positive quality comes a tendency toward the sin of self-sufficiency and pride. So in His plan for me, there's a safety mechanism to fight those sins. This career I'm excited to have built is based on the embarrassing secret I hid for years.

Our gifts come from God. I questioned God because He wasn't clearing the path for me to give Him the "gifts" I wanted to give Him. Natural talents are often called gifts, not because they're things we're meant to give to God but because He gave them to us.

God gave me drive and communication skills and an over-thinking brain for this purpose He had for me all along.

We are weak for a reason. For me, my weakness became my platform and gave me the sixty thousand words in this book to share who God is and why I can't live without Him. We all have weaknesses, and there is purpose in all of them. Our weaknesses prevent pride. Not just because prideful people aren't fun to be around but because pride and self-sufficiency keep us from truly knowing God. Weaknesses help us understand our need for Him.

How the Miracle Miracled

Because miracles reveal who God is, I'll share a little about *how* God worked this miracle in my life. I never got tapped by a wand or bitten by a radioactive spider that gave me cleaning super-powers. Through the miracle God designed for me, I was able to see the flaws in how I'd tried to change my cleaning ways before.

I was at such a point of desperation when I started my secret slob blog that I started as small as I possibly could. I was so tired of failing. I worked on one new habit at a time. As I wrote about which habits made an impact and which ones didn't, I began to understand how a house is supposed to operate. I learned that one day's worth of dishes is not overwhelming, but two days' worth of dishes is. As an overthinker, this understanding was a gift. I learned how to declutter by decluttering truckloads of my stuff. I trudged through and developed a real process that worked for me. I practiced it. I honed it. I started volunteering to host last-minute playdates!

Because change wasn't instantaneous, and because the ways

I was learning to be successful were different from the ways I'd been taught, I accepted that my struggle with my home was caused by an actual difference in the way my brain worked.

I gained community through my slow miracle. Because I was writing daily, being completely honest, sharing photos of horrifyingly cluttered spaces (while remaining anonymous, of course), I met others like me—others who thought *they* were the only ones. I was as shocked as they were to learn there were so many of us. Through this community, I learned to accept how my brain worked and began to appreciate that God made me this way on purpose. As I shared each realization about myself—such as how I don't see incremental mess and how I suffer from Time Passage Awareness Disorder (a term I made up to describe my inability to estimate how long a cleaning task will take)—others responded with, "Me too!"

I started to see a common thread in those of us who struggle to keep our homes from spiraling out of control: creativity. Responding in agreement with my embarrassing confessions were highly intelligent, wonderfully creative women. They were artists and poets and novelists and bakers and scientists and mathematicians and theatre teachers. I saw that the same beautiful brain differences that help us see the world differently in our hobbies and careers are directly related to us seeing our homes differently. I realized that somehow, someway, a direct connection exists between the creative parts of our brains and the messiness parts of our brains. If I thank God for making me creative, I also need to accept that my struggles with the mundane tasks in my home are related to how He created me.

I loved identifying as creative. I loved writing. I loved directing plays. I was learning that I loved the experimentation and analysis

of entrepreneurship. Acceptance of myself was one aspect of God's slow miracle, and it strengthened my trust in His plan for my life. Realizing my brain was designed instead of defective helped me to relax. I gave myself permission to figure out how to keep my home under control in a way that made sense to my brain, even if it was different from what the "experts" said to do. I don't use that as an excuse but rather as freedom to not feel like a failure when traditional organizing advice doesn't work for me. That advice is written by people who were created to think differently than I think. Accepting that I was created by God to have exactly the brain I have was a lovely, freeing realization.

As I accepted that God had made me this way, I also accepted that there was purpose in my weakness. Seeing the purpose in my weakness was pivotal in my own spiritual growth. In 2 Corinthians 12, the apostle Paul talked about a thorn he had begged God to remove. Three different times, he asked God to remove it. I'd asked God to remove my thorn many more than three times.

God answered Paul, and through Paul sharing that answer, God answered me too: *no.* "My grace is sufficient for you, for my power is made perfect in weakness" (2 Corinthians 12:9).

Ummmmm, yes, that. Exactly that.

When Paul stopped resisting and embraced the fact that God was using his weakness, he realized that his weakness had a purpose. The energy he'd put into begging for its removal instead went into worshiping God for His master plan. Accepting my weakness, *even being thankful for my weakness*, changed me. Seeing its purpose helped me to understand, in an ongoing and tangible way, my own lack of power and my need to depend on God.

That was my slow miracle. I didn't get a lightning bolt of understanding that turned me into the world's neatest house-keeper, but I got a gradual acceptance of who I was in relationship to God, and I learned that He made me exactly the way He did because He loves me.

God also provided the miracle of this ministry. This miracle was slow because I had to establish the right to lead by figuring out what worked in my home and sharing the reality of the process. Had I started out rallying people to save money and sell on eBay and get dinner on the table, things that were fun and easy to me, even if I had cured my slob problems *before* writing about them, I wouldn't have met the true needs of so many of My People. I am told again and again that those first years of daily blog posts—sharing the ups and downs with real-time thoughts and photos—are exactly what the hopeless person needs to see.

I get it. I was at rock bottom, and I didn't think anyone could understand what I was dealing with in my home. Starting as a secret self-improvement project provided the documented proof that the skeptical woman needs to believe the strategies that work for me can actually work for her.

Not that I started out with any intention of helping others in this area. Accepting that my weakness was given to me to bring me closer to God was one thing. Accepting that God wanted to *use* that weakness to minister to others was a whole 'nother thing. When people started asking me to teach them how to do what I was doing, I rolled my eyes. That was a different level of purpose-acceptance. For two and a half years, I firmly refused.

Ultimately, though, God showed me I did have something to share, that this housekeeping-for-the-hopeless thing was the ministry I had desired all along. I just never would have put it in

a business plan, because it couldn't possibly have made any sense to me until it had already happened. That was a slow miracle.

God knows me and knows what makes me tick (and keep ticking), so His plan was much more fun than mine would have been. His plan allowed me to be me, to not have to pretend. I didn't start for eighteen months because I was afraid of having to hide part of myself. I just never considered that *not* hiding my deep, dark secret was even an option.

I'm thankful for slow miracles.

The Problem with Planning Our Own Miracles

Miracles are miracles because they come from God. He does them His way. I sometimes find myself predicting miracles. I think I'm just rehearsing a "Praise God!" speech for the future by telling my imaginary audience how this answered prayer will surely lead to three more miracles! *I'm thankful my kid passed that test, but what if that test leads to a scholarship, which leads to a PhD, which leads to a Nobel Prize?!* I tell my imaginary audience an inspirational story about "what happened" even though it hasn't happened yet. I do this partly because of the drama God put in my heart when He made me, but I have to be very careful not to let this tendency make me miss, or even reject, what God wants to do in my life.

In every situation, miracles are designed by God specifically for the person who needs to see God. When Naaman went to Elisha to be healed of leprosy (the most isolating and life-altering disease in his time), he almost didn't get healed simply because the path to the miracle didn't look the way Naaman wanted it

to look. Second Kings 5:11 says, "Naaman went away angry and said, 'I thought that he would surely come out to me and stand and call on the name of the LORD his God, wave his hand over the spot and cure me of my leprosy.'"

Naaman wanted the big miracle. He was looking for magic. He'd probably heard stories of miracles that looked like magic happening to other people. Is it too much to ask for a little pizazz? Some wow factor?

But God didn't do that for him. He knew Naaman, and He knew Naaman's heart. Naaman desperately wanted to be rid of this disease, but he didn't understand that miracles aren't about the healing; they're about the One who heals. Naaman was told to do something illogical and somewhat gross. Elisha told him to wash himself seven times in the Jordan River, which was far from pristine. This made so little sense to Naaman that he rejected Elisha's instructions. He refused to do it and "went off in a rage" (verse 12). Thankfully, though, Naaman's servants talked some sense into him, and he decided to obey and was healed.

Miracles don't all look the same. My miracle needed to be slow. The slowness helped me recognize it as a miracle, as the process helped me see and know God more. The slowness of my miracle also helps many other people.

When people learn of me and my strategies, many want to know how long it took to get my house under control. I know they're asking because they want to write "Finish Decluttering" on their own calendar. I always tell them to go back and read those early, daily blog posts that started in 2009. In those, they'll find a real-time record of the change as it happened, oh-so-slowly and not-so-steadily. The miracle comes alive. There's more hope in that.

Chapter 6

The Myth of Arrival

One of the most logical and harmful excuses in my old list of Reasons My House Is a Wreck was the one about how Future Me was going to get myself together and all of this wouldn't be hard anymore. This is the Myth of Arrival: the delusion that one day in the future, everything will be easy. Whatever "everything" might mean.

Words can go in or out of style like bell-bottoms and skinny jeans. A word that was once positive can turn into pseudo profanity. In my time as a mom, *balance* has been one of those words.

Sometimes balance is discussed as something positive that we seek. In the parenting world, balance was once the goal. Balance was the answer to the question of how much time you should spend on your career, your family, and yourself. But at some point, I started hearing the word *balance* said with an accompanying sneer: "Balance isn't possible." "Stop worrying about balance." "There's no such thing as balance."

As I understand it, the idea behind this negative view of balance is that we're supposed to be completely engaged wherever

we are. If we're at work, we need to be fully at work. If we're at home, we need to be fully at home. If we're with our families, we need to be fully with our families. Doing two things at once isn't possible, so don't even try.

I agree with some of the arguments for balance and some of the arguments against it, but I think it is most helpful to understand what balance actually means.

Balance *is* important. Life can get out of whack pretty quickly, especially for someone like me who loves a project, dives into that project, and then proceeds to ignore half of my reality. Balance is required for us to function in the physical world. Since the physical world helps us understand spiritual realities, let's talk about that.

Balance is a basic and necessary life skill. We just tend to take it for granted. When babies tenuously get to their feet, they're completely focused on balancing. When you stand up from a chair, you're doing the same thing. You just don't have to think about it because you've had enough practice and have built up enough strength to not worry how it will go. But if you lose your strength due to injury or age or another factor, standing up becomes difficult again. Something you took for granted becomes challenging or even impossible. I've never worried much about the aesthetics of my own rear end, but after caring for my mother-in-law, whose mobility and independence were severely limited when she lost strength in her legs after years of spinal issues, I've become pretty passionate about maintaining strength in my bohiney and thighs. I now understand what happens when you can't sit down or stand up on your own. If you can't sit down on or stand up from a toilet . . . life gets exponentially harder.

Holding On and Letting Go

I've done a little yoga. That might sound like humblebragging, but it isn't. I mean an actual very small amount of yoga. I've been to several yoga classes and mostly liked them. And I've learned a thing or two about balance by doing yoga. (Again, an actual thing or two at the most.)

Yoga looks easy. Those who haven't done yoga (like me a few years ago) wonder why people call yoga a workout since "all" they're doing is staying still in whatever pose the yoga instructor has chosen. The uninitiated might even roll their eyes *until they try it.* That's when the truth about balance becomes clear. Balance is a place of tension. Of concentration. Of focus. That tension will get my sweat glands a-pumpin' and make me sore the next day. *Just* from purposely working to achieve balance.

I used to think getting to a place of balance in life meant getting to a place where I could relax and rest. I believed balance was a magical point at which I'd finally be able to sigh with relief and chill. *But balance isn't that.* Balance is what a tightrope walker is striving for to avoid plummeting to the solid ground. Every muscle in the body is involved in balance. If there are such things as ear muscles, I'm betting they have a part to play in the balance that is needed to stand on one foot.

Balance is a weird concept, though, because you can't balance harder. Balance is about tension but also about letting go. My yoga instructor constantly reminds us to breathe. I find myself wanting to hold my breath and push through to achieve the balance, but that's the exact opposite of what you're supposed to do.

Tension and lack of tension? Stay with me. Balance isn't something you can do real quick and then be done. It's a state

of being. Tension paired with letting go. Balance is an ambiguous concept, and that ambiguity makes it the perfect image for understanding the equally ambiguous and necessary concept of balance in our nonmuscular world. There's no such thing as working hard until you achieve balance, then being done with balance and moving on to something else. Balance is ongoing and necessary forever. *Sorry.*

In my own life, I'm never technically *not* helping people with their homes. My books are being read at any given time somewhere in the world. I have enough content on the internet that someone, somewhere is always watching a YouTube video of me or listening to one of my podcast episodes or reading something I've written. I can see this in the analytics dashboards for all of these internet locations.

Also, I'm never *not* a mom. As I wrote the first draft of this chapter, I was away from home for two days in a little trailer in the middle of actual nowhere so I could focus exclusively on my work and get a big chunk of writing done. I was able to do this because the family I left behind included three drivers with three vehicles. Thankfully, my husband has no problem putting chicken in the Crock-Pot. But I'm still a mom. I still got texts asking where we keep the rice or if I happened to remember the last place I saw the weight-lifting belt or how long before leftover shrimp goes bad. I still felt compelled to remind the eighteen-year-old what time he needed to pick up his thirteen-year-old sister from play rehearsal. And I missed my family the entire time I was gone.

Balance is reality. Humans aren't one-dimensional. We have multiple identities that exist simultaneously. Being the CEO of a company doesn't make you less of a parent, and being a daughter doesn't make you less of a mother.

When I first started *A Slob Comes Clean*, I viewed it as a project. An opportunity to learn about writing on the internet (the thing I was desperate to do) while focusing on my house and getting it under control once and for all. The biggest thing I had to learn about keeping my house under control was that *once and for all is not a thing.*

Resisting that fact of nature hadn't helped me. Thinking I was working toward being done was a huge part of my problem in all the years we lived in Disaster House. Gritting my teeth and working until I was exhausted to get the house clean from top to bottom ultimately wasn't helpful. But accepting that working on my home will never end and that the little things I do each day help make the balance possible? That's helpful.

Achieving balance in my home means working and maintaining and doing what needs to be done while also accepting that there isn't a finish line. There may not be a "once and for all," but there *is* a goal. I want my family to live a healthy life in a home where we can relax and have space to do the things we want to do. But achieving that version of my home means maintaining that version of my home. It never ends.

What Does Jesus Say About Balance (and Mess)?

Where's the balance between Jesus not caring about my messy house and my messy house being something I care deeply about? You know by now that for years, I desperately begged Jesus to change me into a neat and tidy person. He showed me in His Word that He cares about my heart. He cares about my

motivations. He cares about my focus on Him. He was never waiting for me to get my house under control so He could love me or use me. He already loved me just as I was, because He made me the way I am. And being who I am means that keeping my house under control is a very real struggle for me.

But then I hear someone argue that not doing the dishes is laziness and not picking up after yourself is selfishness. Laziness and selfishness are sins. So how is my messy house not (necessarily) a sin?

My heart is the key. If I'm leaving a pile of trash on the coffee table because I know someone else will pick it up if I leave it long enough, that's selfishness. That's sin. But if I'm as surprised as anyone to see the pile because I absentmindedly dropped things there at random times until they turned into a pile, that's not a sin as long as I deal with it. Even if dealing with it means I have to take a deep breath and audibly talk myself through my five-step decluttering process.

The existence of the pile isn't a sin. The heart behind the pile is where sin can live.

A big lightbulb moment about my Slob Problem was the realization that I don't see incremental mess. I call this *Slob Vision*. I notice spaces that are perfectly clean and orderly, and I notice spaces that are totally overwhelming disasters. But I don't notice the buildup. I don't see one piece of paper that I dropped on the dining room table as I hurried out the door. The table is still mostly clear, so that one piece of paper doesn't even register in my brain as something I need to deal with. Meanwhile, my brain is subconsciously adjusting to the dining room table having something on it, so it also doesn't register when another piece of paper ends up there. Or a small pile of mail. Or an Amazon

box. Or a screwdriver. Or some pizza boxes. Until suddenly, I see the dining room table one day and am completely overwhelmed by the mess. (Usually, this happens when I find out someone is coming over.)

So is it a sin to have a messy dining room table? Is that kind of messiness the opposite of godliness? I already feel frustrated by the mess, and if I believe the mess is also a spiritual failure, I fall into despair. I don't want to sin, but I cannot figure out how in the world to avoid having a table with a pile.

Sin is a heart issue—an issue of what my husband calls (in his distinctively Texan accent) your "wanter." Your wanter is your motivation. It's what drives you. With the Holy Spirit living in you, your wanter (what you want) is changed from what it was before you believed. That pile of stuff on the dining room table is not the sin, but if I don't let someone who needs a place to feel safe enter my house because I'm embarrassed, that's pride. Pride is a heart issue. That's where sin enters this scenario.

I've felt completely welcomed into homes that were cluttered or dirty, and that's because the heart of the person welcoming me was in the right place. They were serving me, giving me a safe place to be. If I'm judging them, it's *my* heart that is wrong, *my* heart that is sinning.

But if I'm on the other side, bringing someone into my home while knowing it's an uncomfortable mess and purposefully choosing not to do anything about it because it's *their* responsibility to not judge me, then my heart is being self-centered. I'm being lazy. I'm sinning. It's not an easy answer. It's a balance.

The Bible clearly defines many sins, but the Bible also includes many examples of sin as a heart issue. For instance, let's explore the idea of motivation. Is your motivation in doing

something (such as keeping your house) to prove (even if only to yourself) that you're better than someone else? That's sin. Is your motivation to not be bothered by someone else's problem? That's also sin, especially if it directly affects the other person's chance of seeing God working through you.

Paul talked about so many situations like this in 1 Corinthians. The first few issues he addressed were pretty simple. He reminded his Corinthian friends of what they knew to be right or not and why. But then he got into situations of conflict where, technically, neither side was wrong. These weren't cut-and-dried situations.

Whether those things were sins was determined by the heart's intent. Pure intent is determined by a lack of selfishness and a desire to help the other person know God more. Love is the defining factor for every action.

It's All About Love

First Corinthians 13 is known as the Bible's "love chapter." It was read at my wedding, and I'm pretty sure some of you included it in your weddings too. After addressing so many specific situations with tough answers that always came down to love, I feel like Paul was saying in 1 Corinthians 13, "Oh, my word, y'all! Fine. I'll explain exactly what I mean by the word *love*."

Love was and is the answer to all the questions. Are you loving the other person in the situation or not? Are you considering how your actions and reactions will affect the way they see God? Are you more focused on what you want than you are on what they need? True love is pointing someone to Jesus and

willingly giving up your own personal freedoms to avoid causing a problem in their relationship with Jesus. Love is patient, kind, without envy, and more. Love isn't selfish.

So where does the state of your home become a spiritual issue? In the motivation. Your motivation. Whether you're the one who struggles with messiness or you're the one who struggles with the one who struggles with messiness, are you dealing with the situation in love?

In 2019, my family left the DFW airport completely exhausted after an overnight flight home from Ecuador. My seventeen-year-old son's legs had swollen up throughout the flights, and he could barely walk. We'd gone from thinking we might need to take him to the doctor the next day to figuring out how we could stop at a clinic on the way home.

But as we left the airport, before we even stopped at the toll-booth, my husband's phone rang. My mother-in-law's assisted living facility was calling to tell him she had passed out and fallen in the hallway. An ambulance was on the way. Something made him ask if his mother was breathing. She was not.

That was a bizarre and horrifying hour's drive. We knew she was gone, but no one could tell us that until we arrived at the hospital and were taken into a side room to talk to the doctor. Meanwhile, my son's legs continued to swell, and our shock over my mother-in-law's death was combined with rising fear over what was going on with our son. We decided I'd check our son into the emergency room while my husband met his sister and her family—who were rushing to get there from an hour away—at our house. Our messy house. I'm not one of those people who can't leave for a trip without cleaning first. (Like, not at all.) Thankfully, it was nothing like what it would have been

pre-deslobification, but I knew it didn't look the way I liked it to look when my sister-in-law visited.

I squashed the shame that threatened to color my cheeks and headed to the ER. After many hours of waiting and IV antibiotics, then after explaining our unique situation and asking if we could go home when the doctor debated whether to admit my son, I arrived at our house to find it full of people. I walked in, attempted to ignore the piles of packing debris scattered throughout the living room, and then sat down to grieve. Most of all, I shut my mouth. I'm an overtalker. I wanted to say something, to explain what the piles were and why they were there. I wanted to make an excuse for why the bathrooms were less than sparkly. Honestly, I wanted to ask why my other family members hadn't moved things out of the room before people arrived.

But I shut my mouth. The grief and shock were enough for everyone to deal with without Mama's ranting and raving. The guests needed to feel comfortable and welcomed—not embarrassed for me or like I wasn't glad they were there. Had we been home when this happened, I'd have shown love by throwing all the mess into a closet to make things as comfortable as possible for our guests. As it was, I had the opportunity to show love by letting them see my mess and choosing my own internal embarrassment over their discomfort.

Here's more good news: As long as you're living, it isn't over. We live under the umbrella of grace. We're loved. We're forgiven. Even for the sins we commit after we accept God's forgiveness, because that forgiveness is once and for all. It's not a thing we have to go back and beg for again and again. We will continue to mess up. Everyone does. But even if the mess of my dining room table happened innocently enough, and then I sinned by selfishly

telling my friend she couldn't come over because I just didn't feel like dealing with the mess, I'm already forgiven for that. I can repent, move on, and do better next time.

That's the beauty of grace. Grace means we've been completely forgiven. It's done. Jesus took the punishment for all the sins of my (and your) past, present, and future. And grace means there's absolutely nothing I could have done or need to do other than accept His forgiveness and the relationship with Him.

With that grace, I also receive the Holy Spirit. He lives in me as a deposit guaranteeing my relationship with God. Because the Holy Spirit lives in me, I am different. My "wanter" is changed, which affects my actions, even though my actions have no bearing on my being forgiven. These two things coexisting, this balance, can feel hard to grasp: I'm motivated to change my actions because I understand my relationship with God isn't dependent on my actions. Tension and relaxation. Holding on and letting go. Working hard and resting. That's the reality of balance.

Ideal Rest

When I think of ideal rest, I think of sitting in the shade on a sunny day. Shade is used again and again in Scripture as an image of God letting us rest in Him. Psalm 121:5 says, "The LORD watches over you—the LORD is your shade at your right hand." It's an image I thought was obvious. Give me shade. Let me chill. As with most things, though, the more I know God and the longer I live, the better I can see more depth to explore.

My husband and I went to Punta Cana, Dominican Republic,

for our twentieth anniversary. We spent a lot of time on the beach, and it was lovely. We tried the pool, but that was where fun people hung out. We're not that fun.

Over the next few days, we decided our favorite thing was to grab beach chairs under an umbrella, read, and *nap*. The ocean breezes and rhythmic waves were the music of peace to my ears. Getting the angle of the beach chair just right, then rolling up a beach towel to use as a pillow? Perfection. I can feel my shoulder tension releasing just thinking about it. The shade was everything. I have no interest in tanning, so the shade provided protection I needed and made the temperature perfect.

But as soon as I felt completely and totally relaxed, one pinkie toe grew a little warmer than the rest of my toes. Then my elbow grew warm. I realized the shade was moving. (Technically I suppose the earth was moving.) I had to adjust my position to stay in the shade. Little by little, I adjusted, all throughout my relaxation time. By our last day there, I had a system. I looked for a spot with a second umbrella nearby that would shade me pretty quickly after the first umbrella stopped doing the trick. I grabbed an extra towel to drape over my toe or my elbow if I needed to. The system wasn't perfect, and I had to stay aware, but it helped me stay in the shade.

In life, there's no arrival point where everything will be easy. There will never be a time, here on earth, when we get to be done, when we can coast, when relaxation will be the thing we get to do forever. As a young mom, as soon as I figured out a routine that worked with my infant, that infant started toddling and another infant came along. As soon as the kids were all in school (a favorite promised land of toddler moms), I gained new responsibilities for whatever new things I embraced, and the old

routine had to be reworked. And on and on it goes. Forever. My parents are "retired" and busier now than they've ever been in my memory.

Balance is the coexistence of the things we have to do with the things we can't control. To live is to change, so every action we take and situation we face must be assessed according to what God is asking of us now. Right now. In this moment.

I'm not saying, "Don't bother cleaning your house because Jesus doesn't care."

Instead, I'm saying to stop thinking of each pile as something Jesus is mad about. Deal with that pile. You may have a really good reason for that pile, and Jesus knows that. He knows how your brain works because He designed it. He knows you spent the last month dealing with your sick kid or dad or best friend, writing up that proposal at work, organizing a field trip, or whatever it was you were doing—and He knows that's the reason your house is out of control.

Try again. Deal with that messy pile. Keep working on your house, but not because Jesus is mad that it's messy. He cares about your heart. He understands the reason behind your sink full of dishes, even if your sister doesn't.

And God put this book in front of you. He introduced you to someone (me) who understands what it's like to be you. But this person who knows what it's like to be you has also figured out a lot of things: ways to keep the house livable and welcoming despite the natural tendency to let it fall into chaos.

There's hope for your home. I can say that for sure. But there's also hope that's completely separate from your home. That hope is Jesus, and He covers it all.

Chapter 7

One Size Doesn't Fit All Hearts

The story of the rich young ruler is one I heard as a child, and it impacted me as an adult through David Platt's Bible study *Radical*. Honestly, I was surprised to learn this story is sometimes used to convince people they should declutter. That's not the message I ever got from it. But since this is a book about Jesus and messy houses, let's talk about it.

When I read through the Bible in 2019, I kept a notebook where I wrote down thoughts about what I was reading. I marked the story of the rich young ruler as "highly impactful" in my notes. The biggest impact, though, for the purposes of this book, comes from comparing it to the story that comes right after it.

Here's the rundown. Jesus spent His time teaching people what the existing scriptures had meant all along. He explained who He (God) is and how life (as He designed it) works.

Jesus was a very good teacher. Throughout the first four books of the New Testament (books referred to as the Gospels,

which tell the story of His life on earth from four different perspectives), Jesus taught and people listened. Crowds gathered. His words opened people's hearts and minds, and they finally *got it*. People asked questions, and Jesus often answered their questions with parables, which are stories that teach a principle.

The rich young ruler story isn't a parable. It isn't hypothetical. Parables are identified as parables. The introduction to this story shows that we're talking about a real person: "A certain ruler asked him, 'Good teacher, what must I do to inherit eternal life?'" (Luke 18:18). Jesus responded, "You know the commandments," and named a few (verse 20). It's important to note that Jesus didn't say that keeping the commandments is the way to eternal life. He just reminded the man that he knew the commandments.

The ruler's response? "All these I have kept since I was a boy" (verse 21).

Jesus' response to that? Mark 10:21 says Jesus "looked at him and loved him" and said, "One thing you lack. . . . Go, sell everything you have and give to the poor, and you will have treasure in heaven. Then come, follow me."

Matthew 19:22 tells what happened next: "When the young man heard this, he went away sad, because he had great wealth." He exited here. Specifically, he "went away sad."

After the rich young ruler left, Jesus explained to the disciples what had just happened, telling them, "Children, how hard it is to enter the kingdom of God! It is easier for a camel to go through the eye of a needle than for someone who is rich to enter the kingdom of God" (Mark 10:24–25).

Don't freak out if that freaks you out. The disciples were freaked out too—so freaked out that they asked Jesus, "Who then can be saved?" (verse 26).

Jesus responded, "With man this is impossible, but not with God; all things are possible with God" (verse 27).

Let's talk about this conversation, mostly because that's exactly what Jesus wants us to do. He wants us to think about His answer and talk about His words and do our best to figure out *what in the world* He was trying to say. There's a detail in one of the Gospel accounts of this story that gives some important insight about this encounter: The guy walks up to Jesus and calls Him "good teacher" (Mark 10:17). It seems like something about that stuck in Jesus' craw. "'Why do you call me good?' Jesus answered. 'No one is good—except God alone'" (Mark 10:18). This is, honestly, a confusing answer, since Jesus is God. And Jesus had already *very* clearly identified Himself as God.

Jesus wasn't just answering the question though. He was answering the heart of the question, the heart *behind* the question. He was addressing the man's motivation for asking in the first place. The fact that he called Jesus "good teacher" revealed his heart.

The Question Behind the Question

I feel like I understand this situation a little better now than I used to because of the years I've spent as Decluttering Guru of the Internet. (Don't worry. I'm not comparing myself to Jesus.) People like to ask me about clutter. They come up to me after a speaking event or they send me an email. Some have just learned about my system, and some have read everything I've ever written. I know enough now to (usually) understand the question behind the question. Jesus is Jesus, so He understands every time.

Sometimes I know what they're really asking because I used to be in the same situation with the same question and the same excuses. Sometimes I know what they mean because I've heard the exact same question many times from many different people.

When Jesus answered the rich young ruler that no one is good except God alone, Jesus definitely wasn't saying *He* wasn't good. He was (is) totally good and totally God. He wanted the man to examine and acknowledge his own motives: "Why do you call me good?" (Mark 10:18). Calling Jesus "good teacher" is very different from acknowledging that He is God.

Jesus went on, "You know the commandments: 'You shall not murder, you shall not commit adultery, you shall not steal, you shall not give false testimony, you shall not defraud, honor your father and mother'" (verse 19).

The guy, relieved to hear he was already doing the right stuff, responded, "Teacher . . . all these I have kept since I was a boy" (verse 20).

When people ask me questions, some want advice. But the question behind the question for others is asking for confirmation that the hard thing can't actually be done. They want me to agree that their husband or wife or daughter-in-law is the one who needs to change, not them.

Some people want to be helped. Some people want to be right. Ultimately, the difference is whether they are willing to change.

I believe this guy (who at this point hadn't yet been identified as rich) wanted to be right. He knew people were talking about this Jesus person. He knew people's lives were being changed by Jesus' teachings. But I don't think he thought *he* needed to change. He just wanted confirmation that he was on the right track.

I understand. I love being right.

But Jesus had one last thing to say to this man after He "looked at him and loved him." Don't miss the fact that Jesus loved this man. He wasn't stickin' it to him or setting him up to fail. "'One thing you lack,' [Jesus] said. 'Go, sell everything you have and give to the poor, and you will have treasure in heaven. Then come, follow me'" (verse 21).

Jesus addressed the man's privilege because He saw privilege for the blindfold it was. Jesus desperately wanted that blindfold gone so this man could have eternal life. He wanted the man to acknowledge that physical possessions are nothing, and if he truly understood who Jesus was, he would acknowledge the value in giving all of them away for the opportunity to spend his life with the incarnate God of the universe: "Give it all away. Change your life completely, and follow Me."

Yet here's what happened: "At this the man's face fell. He went away sad, because he had great wealth" (verse 22). At this point in the story, we find out what Jesus knew all along. The man was rich. He was self-sufficient in a way many people assume would solve all their problems. When this rich man approached Jesus, he wasn't looking for new understanding as much as he was looking for confirmation he was going to be okay. That living the way he was living was all good.

The Risk of Following Jesus

I'm consistently slapped in the face by stories like this of someone rejecting God because they want to hold on to their money or their lifestyle. I've never been full-on poor, but my husband

and I are a lot more comfortable now than we were when we first got married. I remember crying actual tears over an unexpected bill for our share of party food in the first year of living on a single income. That's a first-world problem for sure, and I don't compare our situation to someone who doesn't know where their next meal will come from—but it makes me grateful for what I have now and realistic that letting it go would be really difficult.

I'm going to get super blunt and honest here. I have a good thing going. I'm not filthy rich, but I make an actual living by teaching others what I've learned about cleaning and organizing. My income is more than what I would make using my teaching degree. Because of this made-up job, my husband and I were able to buy a little land with a pond, a place where we hope grandkids will be excited to come visit us.

But this book you're reading right now is a departure from the content I usually share to pay my bills. And it's a Christian book—one I hope deals in actual biblical truth. The Bible is clear that when you talk about it, some people are going to hate you. I hate being hated. But it might happen, which could affect the existing income I make from my cleaning and organizing content.

Part of the process of being willing to share this message has been acknowledging that sharing it might change everything. I could alienate the part of my audience who doesn't want to hear me talk about Jesus. I may alienate people who vehemently disagree that Jesus doesn't care about my messy house. Publishing this book could shift or eliminate the trajectory of the books that keep selling—the books we're counting on to help get our kids through college.

When I think about the amazing opportunity this particular

rich guy had, I wonder how I would have responded to the same opportunity. He had the opportunity to know, before it happened, exactly what he would lose if he followed Jesus. I wonder how I would respond if Jesus said, "Dana, writing this book is going to remove everything you've built up to this point. The advertiser money will go away. People will reject you and stop buying your other books."

Putting it that way reminds me of the initial hang-up I had about writing, back when I wasn't writing about my weakness because that option had never occurred to me. I was afraid to write about motherhood while my house was a wreck because I feared people would throw out everything I'd written that was good and true if they found out what my house looked like. What if readers rejected what I've learned about Dishes Math because I "threw science away" and focused on my faith, something a lot of the world scorns?

I get the rich young ruler's hesitation. At a quick glance, I think I'm better than him, but when I stop and get real, I'm afraid I'm not. I believe the real question is, *Am I willing to do whatever Jesus asks me to do?* Am I willing to give it all up, anything and everything, to follow Him? Am I willing to give up security? Am I willing to give up the confidence that I'll be able to pay my bills? Am I willing to give up the house I have and the life I know to follow Jesus?

How do clutter and messiness fit into this picture? As I mentioned, some see decluttering as the logical solution to Jesus asking the man to get rid of all his stuff. That's valid. I know people who sold everything they could and gave the rest away in order to do what Jesus was asking this guy to do. They moved to a new place when God asked them to go.

But Jesus was talking to one specific guy here. Jesus was telling this one particular rich guy what he needed to do, and He knew the answer the guy was going to give before he even gave it.

The guy wanted to know what he needed to *do* to have eternal life, but he didn't want to *give up* anything. Doing is easier. I love having a list of things to accomplish. Giving up? That's harder. Letting go of control legitimately gives me heart palpitations.

The rich young ruler knew the rules. He'd studied them carefully. *But he missed the heart of the whole matter.* He missed that it's not about following rules but about total obedience and the willingness to do anything God asks. It's about giving every single part of our lives to God for Him to use as He pleases. If we hesitate, that is a God-given clue that we need to pray for help to trust God completely.

Jesus zeroed in on this guy's personal issues. Control. Self-sufficiency. Keeping what he earned and deserved. Being right. But "sell everything you have" isn't a one-size-fits-all answer. Being *willing* to sell it all or give it all away *is* a one-size-fits-all answer, but only if that's what Jesus is asking of you.

It's important to keep reading. In the book of Luke, *just* after this account of when Jesus told a rich guy he needed to sell everything, Jesus was thrilled when one of the next guys He encountered gave half of his possessions to the poor.

The Heart Is What Matters

Have you ever read about Zacchaeus? If you went to children's church in the 1970s, you probably know him as a "wee little man." Zacchaeus was a tax collector. Tax collectors were

wealthy (just like the last guy), and many people considered them crooks.

Zacchaeus was short, so he climbed a tree to be able to see Jesus over the crowds when he heard Jesus was coming his way. Jesus approached Zacchaeus and told him to come down from the tree, explaining that He was going to his house. In response, Zacchaeus hopped right down and welcomed Jesus. Gladly. These are the actual words used to describe his reaction: "He came down at once and welcomed him gladly" (Luke 19:6). On his own, Zach said to Jesus, "Look, Lord! Here and now I give half of my possessions to the poor, and if I have cheated anybody out of anything, I will pay back four times the amount" (verse 8).

Jesus was totally cool with that. He didn't say, "Well, okay, Zacchaeus, but are you willing to give everything? To do more? To get rid of *everything* you have and follow Me?" Instead He said, "Today salvation has come to this house, because this man, too, is a son of Abraham. For the Son of Man came to seek and to save the lost" (verses 9–10).

The Son of Man (Jesus Himself) came to seek and to save the lost. The ones who look to Him for answers. The ones who don't go looking for validation that they're already right but who ask Jesus to tell them whatever they need to know.

The heart is the difference in these situations. Not the amount of stuff being given away. Had the rich young ruler responded to Jesus' instructions to give away *everything* by saying, "Here and now I will give *half* of my possessions to the poor," I doubt Jesus would have celebrated. It isn't about the number of possessions we do or don't give up but about fully doing what Jesus asks of us in our particular situation.

The story of the rich man who went away sad because he

didn't like what Jesus told him isn't a prescription for decluttering. It's an example. Jesus saw the hearts of the men in these two stories, and in both situations, their stuff reflected their hearts. One wasn't willing to see Jesus as his authority, worthy of obeying to the point of giving up life as he knew it. One recognized Jesus as the complete life-changer He is and gladly changed his life.

Your heart and your life situation are unique. Your heart and your life situation are fully and completely known by God. He knows your motivations, your intentions, and the things that hold you back from truly following Him. Jesus looks at you and He loves you. Ask Him what He wants of you, and He'll show you. Whatever that is, He'll provide what you need to follow Him.

Chapter 8

Paying for Toothpaste Isn't a Sin

*O*nce upon a time, I couponed. (Yes, *to coupon* is a verb.) I was a *couponer.* (That's a noun.) I was one of those people you hate to get behind in the checkout line. Customers behind me weren't irritated for long though. I was super organized, with a portable, alphabetized filing system. I knew exactly what I was doing, and my transactions took only a few seconds longer than that of the average distracted, couponless shopper with the same number of groceries.

I got into couponing as a stay-at-home mom trying to save money. That obsession replaced my garage sale habit of buying other people's junk and then eBaying it. My eBaying sent me and my clutter issues to rock bottom. (Yes, *to eBay* is also a verb.)

I researched grocery and drugstore sales and planned out shopping scenarios. I made backup plans in case the frozen strawberries were gone. I'd come home and set up displays of shampoo and tuna on the coffee table to make my husband guess

105

how much I'd spent. (His favorite game.) It was fun. It was time-consuming. It was an obsession.

Couponing was a legit game to be played. You just had to want it. You had to work for it. I distinctly remember telling people, "There's no reason for someone to ever pay for toothpaste." Toothpaste was almost always on sale somewhere with some sort of matching coupon, and if you combined the sale and the coupon at just the right time, you could legally walk out of the store with free toothpaste.

All I had to do was pay attention. I simply had to know when and where the sale was, cut the right coupon, read it carefully so I didn't grab the wrong size tube, and arrive at the store before all the other crazy couponers cleared the shelves. Silently in my heart (and probably out loud to my husband), I looked down on people who spent cash money for toothpaste. In the midst of this passion/obsession, I repented of the years I'd paid for toothpaste and couldn't imagine a future where I would pay for it again.

Then my next passion took over, and I no longer snatched the coupons from our Sunday paper. I was busy writing. I didn't have the time or the internal drive to stop at three different stores to get what each had on sale.

A year or so later, I finished up the stockpile of free and fancy toothpaste I'd collected in my couponing days. I spent ninety-seven cents on a small tube of the basic paste I'd used before couponing. I decided I was more than happy to pay ninety-seven cents for toothpaste so I could eliminate an hour (or more) of wheeling and dealing from my life. I felt sheepish over the thoughts I'd had about toothpaste-buyers during the wheely-dealy years of my life.

Here's the thing. I tend to become very passionate about

certain things. Sometimes I run into people who are equally passionate about the opposite thing. We can both be not wrong. It isn't wrong to coupon according to the rules. Companies (correctly) count on the fact that most people don't care enough to use every coupon to its absolute fullest potential, but coupons exist for the people who do.

People doing things differently from you and me doesn't necessarily mean they're wrong. Just different.

Lazy Versus Different

Laziness is a tough issue to tackle. Bringing it up (again) kind of feels like I "doth protest too much." Instead of defending my own tendencies that others might judge as lazy, I'll focus on my own tendency to judge others for being lazy in other situations. Spoiler alert: The judger in these situations is the bad guy. *I am the bad guy.*

When I see another person struggling with something that feels easy to me, my automatic assumption is that they're just being lazy. It's hard for me to wrap my brain around the idea that this thing is really and truly hard for them. And if something is challenging to me, but I do it anyway, I feel even more justified in my judginess.

Warning: I'm about to talk about some things I used to judge people for. Please stay with me even if you feel like I'm talking about you, because God did set me straight. (You'll like that part.)

I used to judge people for not cooking. I was passionate about feeding my family food I cooked from scratch. I couldn't understand people who didn't cook the way I did. I'd inwardly raise my

left eyebrow when someone mentioned how much money they spent on takeout each month, or if it seemed like they expected applause for baking some chicken. I fed my family meals I made, almost never from a box, on the daily. I was proud of that. Excessively proud.

One April 1, I made an April Fools' dinner for my family. I used Laffy Taffy and Starbursts like Play-Doh to shape "peas and carrots." I made "chicken nuggets" out of banana slices dipped in graham cracker crumbs and piped food-colored mashed potato "frosting" onto meatball "cupcakes." I was so stinkin' proud of myself. I couldn't wait for my kids to begrudgingly take a spoonful of peas and carrots, only to find out they were *candy*! They were going to be thrilled. I would be the best and funnest mom ever.

That night at the dinner table, my kids loved eating candy instead of vegetables. They laughed when they realized why I'd insisted they eat their cupcakes first. Everything was great until my daughter took a bite of a banana nugget. She burst into tears and cried so hard (and so loudly) that it was a long while before we could figure out why in the world she was so upset. She was devastated that the chicken nuggets weren't actually chicken nuggets. She had been so excited because we never, *ever* had chicken nuggets for dinner. And then they were bananas. Not funny at all in her seven-year-old opinion.

I tell that story because it's one of our family's favorites but also because it feels really good to tell it. Did you catch that my kid was thrilled to eat chicken nuggets for dinner? Because I, as a rule, served my family *actual* food. (Read that in an obnoxious tone, and you're reading it right.) I mean, how hard is it to cube a chicken breast, season it with salt and pepper, and sauté it in

a little olive oil? Kids love that. Obviously, they don't love it as much as they love chicken nuggets, but they do love it. People who were too grossed out to deal with raw chicken or other meat? I had zero patience for that. Get over it. Feed your family.

I cringe now at my pride and lack of compassion back then. Thankfully, God helped me get over this ridiculous pride when He showed me I was doing to others exactly what I hated having done to me. In my mind, not cooking from scratch was lazy. Believing this way was easy for me because it made me look and feel good. Meal-planning came easily to me, and I automatically set aside time in my day to make dinner. I always had a general awareness of what was in the pantry and the freezer and knew what I'd need to complete a meal. I naturally worked those things into my schedule. Meal planning systems were interesting to me because they gave me new and fresh ideas for tweaking something I already did well. It never occurred to me that this ability that was second nature to me was overwhelming, daunting, and confusing to others.

But you know what else isn't technically mentioned in Proverbs 31? Cooking. We know Lady 31 got her food from afar and provided food for her family. That doesn't mean she was the one who cooked the meals. I feel like I'm getting food from "afar" when I drive ten minutes to pick up Schlotzsky's on the other side of town or forty-five minutes to get the good ground beef at Costco.

It took me way too long to realize I was wrong for judging those who struggle to cook. It took me way too long to understand that someone else's genuine surprise at finding their fridge empty is pretty much the same thing as my legitimate surprise at seeing a messy kitchen in the morning. Their lack of excitement

over inventing a new recipe out of stuff they find in the back of the freezer isn't a character flaw.

Make Sure You Share Jesus

The Bible includes many examples of wrong and right, but there are plenty of things we deal with in everyday life that the Bible doesn't bother to address.

When I was in junior high, I spent the night at a friend's house. When I asked my friend if I could borrow a towel, she said, "Oh, let me get you a guest towel." She came back with a faded, fraying, thin towel that was at least a decade old. I laughed. I thought she was joking. I pictured the guest towels in my own home, which were nicer than the ones we used every day. But my friend was not joking. She quoted her mother: "The nice stuff is for us. Guests can use the old towels." I still find this puzzling because it's different from the way I was taught and the way I think—but it isn't a sin. I might be able to argue *why* I do things differently, but I can't argue that she was wrong. It's a nonissue.

I once stopped for a free sample at the grocery store. As the woman serving the samples placed a cracker-sized, presliced piece of cheese on a cupcake wrapper, she said something about how this cheese was ready to go, straight from the package. Then she added (what I doubt was in the script), "It's for lazy people, I guess." Oh, how I missed my mother in that moment. *Convenience* was considered a dirty word when I was growing up. Paying extra for cheese that had already been grated was discussed as a moral issue. If it was possible to do the work ourselves, paying someone else to do it was considered wrong.

It's fine to be passionate and share our passion with others in a loving and healthy way. Just also share Jesus. Share grace. Talk about how grace has nothing to do with whether we pay full price for toothpaste, use fancy guest towels, or make our meals from scratch—because grace isn't something we can earn. Laugh about the towels, but be clear that your raised eyebrows are because of your own personal hang-ups, not because the towels have anything to do with a person's relationship with Jesus.

Here's where (and why) it gets messy. Jesus wants to be part of everything in your life and everything in our lives. He wants us to give Him our guest towels (ragged or fluffy). Our finances (having expendable income or barely scraping by). Our time (free or scheduled). The form of my cheese when I stick it in the grocery cart or click it in the grocery app. There are no rules about these things.

Jesus doesn't talk about the slicing or grating of cheese because, for the vast majority of people, the state of their cheese is not a spiritual issue. It could become a spiritual issue, though, if God asks us to give money to the poor and the only wiggle room in our budget is the difference between cheese sliced "for lazy people" and cheese we slice ourselves. But the sliced-ness or non-sliced-ness of the cheese isn't the issue.

If you've made it to this point in the chapter only to be horrified by me and my fellow judgers, I encourage you to examine where you also might be judging others unkindly for their non-sins or legitimate struggles. Crying out, "They just don't understand!" is a lot more fun than acknowledging that I may be the one who doesn't understand something.

To "help" you out, here are some things I've heard said that don't hold up in the court of love for others.

"I can tell everything I need to know about someone by how they maintain their car."

"I can look at someone's fingernails and know what kind of person they are."

I've heard the same said about shoes, hair, clothes, eyebrows, and about whether a person reads fiction or nonfiction or at all, keeps their flower beds weed-free, loves dogs, and more. If you still haven't felt a twinge of conviction, I'll end with this one: judging someone who doesn't take their shopping cart to the shopping cart return. Self-righteousness can feel way too justifiable on that one.

No matter the situation, I have to acknowledge that things that drive me crazy or that I can't imagine doing or not doing may not be sins. It's worth the effort and discomfort to admit that judging comes so easily whereas considering others' situations does not. I'm held responsible for my own heart—my heart behind what I do and why, and my heart behind how I view others.

I've given some silly examples, describing situations when I was in the wrong for thinking about things that don't matter as if they are things that do matter. Whether you're talking about toothpaste or cheese or towels, the fact that not everything we have to do in life has one right way to do it seems pretty obvious. Not one of those examples matters unless I find myself not wanting to teach God's grace. There's no spiritual danger in doing these things I'm passionate about. I'm free to love cooking, to slice my own cheese, and to put away my shopping cart for all the reasons that make these tasks important to me.

But if I refuse to acknowledge that others can have legitimate reasons for not slicing their own cheese, not cooking from

scratch, or not pushing their cart to the return, and that those reasons are neither sins nor qualities of righteousness, then I am in real spiritual danger. My judgment and self-centeredness can cause real harm to me *and* the other person. Included in so many of the thank-you emails I get from Christian women is some version of this story: "Someone at my church told me that if I trusted God more, I wouldn't have all this clutter." Or that her house wouldn't be a mess if she had more faith. So now, the thing she's already bewildered by—the thing that causes her intense shame—has *also* become "proof" that she doesn't have enough faith.

Getting Clear About Grace

The definition of *grace* that I've been taught since childhood is "God's unmerited favor." Grace is all the goodness of God, and all the good things He has to give, being given to me. Grace isn't based on anything I do. It's forgiveness of my sins, Jesus' righteousness placed on me, and the Holy Spirit given to me as the guide and power to live in holiness. I can't earn grace, because grace can't be earned. It can only be given. Grace is not only *not* getting a consequence or punishment I deserve but also receiving a blessing I don't deserve at all. The concept of grace is deep enough to explore for my entire lifetime.

Let's say, for argument's sake, that you still disagree with me about whether Jesus cares about messy houses. You believe that leaving dishes undone or failing to notice and correct a mis-aimed undies-to-the-hamper toss is a sin after all. There's still grace. Eternity still totally and completely hinges on grace and

not (even a little bit) on the panty pile or the crusty cereal bowl. Grace doesn't fill in the gaps after I've done all I can do; it's the entire foundation on which I stand. It makes the great things I do as irrelevant as the bad things I do. The Holy Spirit changes what I want and what I do and gives me the drive to glorify God, but all of that is based on grace and my understanding of what it is. My job, and your job if you follow Jesus, can be summed up by Colossians 3:12–14: "Clothe yourselves with compassion, kindness, humility, gentleness and patience. Bear with each other and forgive one another if any of you has a grievance against someone. Forgive as the Lord forgave you. And over all these virtues put on love, which binds them all together in perfect unity."

It can be hard to bear with the undie-tosser. (Ask my husband.) But Jesus' grace extends to them even if you're convinced they're tossing with malice aforethought. If grace is real, it's real. Sometimes, though, I see in myself and others the tendency to want grace to have a limit. The warm fuzzies are strong as I consider all the ways God has forgiven me, but when a personal pet peeve comes up about someone else, I'm tempted to think, *Oh, but not that.*

If grace feels dangerous to you, stop. If last week's pizza boxes balanced on the coffee table fill you with scorn or rage, ask yourself why grace is absent in your reaction. Examine your motive for withholding grace that isn't yours to dish out in the first place. Take the time to acknowledge your own weaknesses and the areas in which God has extended grace to you. If you don't think you have any, ask God to reveal them to you. He's great at answering that prayer pretty quickly.

If we aren't teaching and modeling grace, we're lying about God. If I'm saying or implying that grace applies to "everything

but *that*," I'm the one causing confusion. Grace is the singular foundation of our relationship with God. Our weaknesses serve the purpose of reminding us of our need for grace.

The opposite of teaching grace is the desire to control. That's why my undies get in a wad when I hear people preaching about cleaning as a spiritual issue. I believe some may fear that if they explain that cleanliness has nothing to do with godliness, the listener will no longer clean. And we can't have that, can we? Let's just not mention that Jesus doesn't care about your messy house. We'll talk all about how He sees the heart and your motivation, but we'll let you keep believing the only possible manifestation of a pure heart that loves Jesus, especially for a woman, and extra-especially for a stay-at-home mom whose identity is tied up in the environment she creates for her family, is a neat and tidy house.

That's all well and good for the person who can't sleep without picking toys up off the living room floor. But what about the person who rocked her baby to sleep and then adeptly stepped over three different squeaky toys (in the dark!) on the way out the nursery door? She crawled into bed with a peaceful smile on her face, only to be horrified the next morning by the stench of rotting mac and cheese at the bottom of the dishes piled in the sink. What about her? If you've never extended her grace, even for her messy house, and acknowledged her legitimate struggle, then she may see her messy house as confirmation that she is innately incapable of pleasing God.

She's completely right that she is innately incapable of pleasing God. Just like the woman who hummed "Amazing Grace" as she wiped down her kitchen cabinets before she went to bed. *Both* women are innately incapable of pleasing God. They both need grace in the exact same measure.

Jesus wants us to encourage people who need encouraging. To talk about what it takes to live comfortably. To welcome others into our homes and our lives so they can experience the love of Jesus through us. Go ahead and do those things. But be clear those are not the things that make Jesus love you.

He loves you because He made you. He loves you exactly as you are because He made you exactly as you are. The only way to please God is by being in relationship with Him. A requirement for that is to have the righteousness of Jesus placed on you, covering all your sins.

Brain differences don't equal laziness. You wouldn't call a child with dyslexia lazy for not trying harder to read. You'd probably even fight someone who did. You'd instead explain to the child that in many ways, uniqueness is their superpower. You'd give them the tools they needed to read using their unique way of seeing the world.

The same is true with this mind-boggling cleaning impairment, whether you were born this way (like me) or circumstances brought it on. There's a difference in how my brain works, and that's a superpower. The world needs people like My People. There are women who won't take on a huge project because they don't know how they'd fit it into their already-busy days of keeping a house under control. Lucky for the world, those of us with Project Brains love big projects, and it never even occurs to us to think about the stuff that will fall by the wayside—like doing the dishes or picking up toys—as we tackle new and exciting challenges.

If the struggles to keep your house out of Disaster Status have blindsided you because they came with a shift in your world or a new phase of life, with babies or caring for loved ones or three

moves in a year, your family and friends need you. Exactly you. Even if you're struggling with the juggling.

Just don't mix it up with sin. Anytime you call a difference in how God created us a sin, you're making a power play. Looking for a way to control.

Every time I make a YouTube video in my kitchen, I brace myself for the comments from people who are horrified to see a container of dishwasher tablets sitting on my counter. Here are some direct quotes:

"Heheeee I see clutter on your counter behind you (laughing emoji)!"

"You should hide that. No one should see it. Just saying . . ."

"Why is that package behind you?"

The first time it happened, I made a video explaining that there are no rules about what should or should not be on your counters. There are truths like Dishes Math, the scientific fact that three days' worth of dishes requires way more than thrice as much time as it takes to do one day's worth of dishes. But arbitrary rules that are ultimately preferences, placed on someone who doesn't mind that silvery box sitting right there out in the open, are harmful.

Why does it matter if I have the dish-tab container sitting out there? I like having it in an easily accessible spot. I don't have any small children in my home, so it isn't a safety hazard. I can grab a tab without moving or twisting or bending or opening a cabinet. Does it matter that it drives strangers on the internet crazy? No. They don't live here. If it drives my friends crazy, they don't say anything (which is why they're my friends).

The second time I made a video in my kitchen, I thought about moving the container just so I wouldn't have to deal with

the rule-maker-uppers. But then, because I'm me, I decided to leave it and be sure it made the shot. Because if people are going to fixate on something that isn't a real issue, I'm going to do that thing as hard as I can.

That's my personality (good and bad), but I am also purposeful. I've accepted that a big part of my job as the public representative for those of us who struggle enough (and don't need strangers imposing their personal preferences on us) is to show My People they aren't alone by showing reality. Do what you need to do to make your home comfortable and functional for the people who live there. Identify the things that don't matter and the things that do. Pay for your toothpaste, slice your own cheese, put your dish soap away, or shine a spotlight on it. Do what you need to do, but rest in the reality of God's grace for you. Whether you get it right or get it wrong, His grace is the only thing that matters.

Part 2

Cleanliness Is a Spiritual Image (Not a Spiritual Issue)

Eliminating the Schtank

Welcome to part 2! We've established that cleanliness is not a spiritual issue, and making it a spiritual issue is dangerous, right? It's dangerous for people who struggle to keep their homes under control and for those who don't. Got that? Okay. Good.

In this second part of the book, I'll share how God has used my intense focus on my home over the past more-than-a-decade to help me understand Him on a deeper level. God doesn't love me more or accept me more because my dishes are (almost) always under control, but I have experienced spiritual growth while working on my home.

The Realities of God's Creation Help Me Understand Him More

I have dabbled in gardening, and I'm pretty terrible at it. But as little as I understand about making things grow, the experiences

I've had uprooting thorny vines and protecting baby broccoli make my brain fire with understanding about spiritual growth and the way the gospel (and sin) spreads. God uses His physical creation as imagery to help me understand spiritual truths. And the deeper I dig in the garden, the more deeply I understand.

Matthew 13 contains three different parables about plants. Jesus used seeds and weeds and thorns as imagery to help His listeners understand faith and truth. In that chapter, He explained what the different images in two of the parables represent. But my understanding is exponentially increased when I get into the dirt myself, yanking with all my physical strength to pull a weed, only to find that it's connected to other weeds six feet away by a complicated system of thorny roots. These physical experiences make me breathe out, "Oh, I got it now," again and again.

All of creation has the purpose of helping us understand God more. In a human-created story, part of an image might illustrate the point the author is trying to make, while another part doesn't. But God designed the world to help us know Him. He created the images themselves, from nothing, for the purpose of serving as images. God is the Designer, and there's so much to learn about His heart from looking at His design.

Runners, carpenters, artists, engineers, and biophysicists can all understand God more through their unique understanding of a unique part of creation. I get to understand Him more through cleaning and decluttering. Yay? I don't love cleaning and decluttering, but I have had more opportunity to think about those things than the average person. This is one way I choose to view my struggle as a blessing. As I work on my home, I learn, understand, and accept basic principles of God's created world. When I'm paying attention, these physical realities help me to

more deeply understand spiritual truths. Just promise me you'll remember it's imagery. I'm sharing how I understand God more through cleaning and decluttering, not giving you something to work on so you can please God more. Pretty please, don't get that mixed up.

The Imagery of Light

The Bible is full of imagery. I love imagery. Imagery uses something tangible or visible to help me understand something intangible or invisible. There's great value in that for my human brain.

One of my favorite examples is the imagery of light. Light was the first thing God created, and light has many purposes. In Scripture, light is used as imagery representing God. First John 1:5 says, "This is the message we have heard from him and declare to you: God is light; in him there is no darkness at all."

God is light.

Light is worth studying because understanding light will help us understand God more. Scientists study light. Artists study light. Gardeners pay close attention to where and when the light hits their gardens. There are so many aspects of light that mean different things to different types of people.

I'll talk about how light relates to cleaning. There are oh-so-many angles to explore. For starters, in the early 1900s, some people were less than thrilled when electric lightbulbs were installed in their homes. Flipping the switches for the first time revealed that their kitchens were much dirtier than they'd realized.

Here's what fascinates me most about light. Light cleans. Did you know that sunshine (the purest, most natural form of light) is excellent for bleaching hard-to-bleach stains? Sunlight is also an amazing cure for schtank. If something smells funky, put it in direct sunlight. The sun (which is totally free) will remove the funky smell.

Sunshine cleans simply through exposure. If a funky-smelling suitcase stays closed up in the yard, not much will happen. But if you open the suitcase and angle it so as much sunlight as possible shines on it, the funk will disappear. No chemicals or artificial scents needed. The smell won't just be covered up. It will go away. No scrubbing. No effort. Letting sunlight clean an item takes more time than scrubbing it with soap and water, but it works better. *Just light.*

Let that image jiggle around your brain for a while. Then think of the spiritual implications of exposing yourself to the light of God. Hearing His Word. Opening yourself up and letting God see you and shine all over you. You'll be changed forever.

The Necessity of Light

We had some basic updates done to our home a few years ago. I tried to get out of the house when I found out the contractor was coming. He did a great job on everything except painting our bedroom. When I returned home after he painted that room, I was appalled. The room looked awful, with large sections of the wall only half-finished. I was confused because the quality of work done in that room was so different from the work he'd done in the rest of the house.

When we talked later, the contractor apologized. He explained that the light fixture in the room wasn't working, so he'd had to paint in the shadows. Oops. *Oh, yeah.*

Technically, the light did work, but I hadn't explained to him *how* it worked. Years before (yes, *years*), the pull cord, which allowed us to turn off the light but leave the ceiling fan on, snapped. Instead of figuring out how to replace the cord, we *adjusted*. If we wanted the fan on and the light off, we simply unscrewed the lightbulb a little. By "simply," I mean we used a stool to climb onto the bed, where we balanced with one foot on the footboard and the other foot on an antique trunk to reach the lightbulb. If the lightbulb was hot, we'd just put a sock over our hand to prevent burning our fingers. *That's all.*

We managed that way for years, but it never occurred to me to make sure the lightbulb was screwed in all the way or to mention our method/madness to the guy painting our bedroom. The bad paint job that had to be redone? It wasn't the contractor's fault. Lack of light was the problem.

Allowing God's light to shine in my life reveals what I need to do and where. I don't have to stumble through my life in the dark, because I have God's personal Word, the Bible, to use as light.

When I physically experience the power of sunlight to disinfect and remove schtank, or when I see the visible effects of working in the dark, I understand God more. I understand His power to change me simply by my being in His presence.

Again, my unique opportunities to understand God are gifts. Some people don't fully understand what I mean when I use the made-up word *schtank*. Or if they think they understand, they only know it as something they've briefly experienced, and never through their own fault.

I know, though, that some of you reading know exactly what *schtank* means. You know the shame that radiates from your hairline, down your spine, and out through your knees when you smell schtank in your own home. Here's a (totally hypothetical) example: I grab a suitcase to pack for an August weekend away. I realize with horror that I never unpacked the suitcase after the trip we took in May. I vaguely remember shoving wet towels and swimsuits into a grocery sack before packing everything into the suitcase, promising myself I'd wash the wet and dirty laundry the minute I got home. Then I left the suitcase in my (hypothetically) hot Texas garage all summer while vaguely wondering what happened to my favorite swimsuit—until now. I open the suitcase and my nose immediately realizes exactly where that swimsuit's been.

Because I've experienced scenarios like this, I have a different appreciation for what light can do. I know the shame and horror and feeling of helplessness that hits my heart when that smell hits my nostrils. I know the feeling of being completely overwhelmed. I know the despair. I've fought back tears and felt the urge to throw the entire suitcase in the trash.

I also know that remembering sunshine is the world's best schtank-remover makes me want to cry in hopeful relief. Most of all, I know the awe and gratefulness of experiencing the power of that sunlight and the resulting absence of schtank.

I get it. I get what light can do in a way others can't. (Not that I don't sometimes throw away the swimsuit.) "Getting it" is a gift. Even though I will never enjoy finding rotten-and-forgotten tankinis and wouldn't wish this experience on anyone else, I can be grateful for the lesson. My personal understanding of the power of light to clean is an opportunity for me to understand God as light in a very personal way.

Open up a trunk full of old clothes, and it's going to smell musty. Expose those clothes to sunshine, and the mustiness will go away. If you live your life without exposure to the light of Jesus, there's going to be mustiness. There's going to be the icky presence of sin. But if you expose yourself to Him and let His light shine on you, the ickiness will eventually fade. Sin is darkness, and darkness can't exist in the presence of light.

The Beauty of Weakness

I had a hysterectomy in the spring of 2019. It was horrible. I'd already had three C-sections and a few minor procedures, but nothing prepared me for the healing process from that major surgery. Mine was even a robotic laparoscopy, which was supposed to be the easiest of all the options for hysterectomies.

I was scheduled to leave the country six and a half weeks after my surgery. The projected recovery time was six weeks, so I assumed I would be perfectly fine to board the plane. I'd heard lots of stories from women who were back to better-than-normal after a hysterectomy in much less time than that. I tried to "take it easy" and ended up making everything worse, so I put myself on what I called aggressive rest. I knew if I had any chance of getting to Ecuador, I had to do everything possible to heal.

Healing is weird because the only thing I could do was nothing. I lay flat on my back for three solid weeks. Healing required nothing on my part but my faith that it was happening. All I could do was stop doing things that prevented healing from happening.

During those hours spent on my back, I thought a lot about

the beauty of weakness. Being reminded that I'm not invincible is a gift. Being forced to be realistic about my inability to control my healing helps me trust in the One who heals. He is in control of healing and, ultimately, of everything.

Since I am a control freak, giving up control to the One I can trust completely is a relief to me. Accepting the futility of trying to control things that were never meant to be controlled by me? That gives me peace.

My favorite definition of *peace*, which I read years ago in the study material of a Bible Study Fellowship lesson, goes something like this: "the conscious possession of adequate resources." When I learned that definition, I was in the middle of a difficult situation that didn't have a solution. The "adequate resources" in that situation (and in every situation) was God. My particular situation was never going to have a satisfactory ending. I would never be proven right. I couldn't know what would happen, but I could know God, and I could have His peace.

I healed from my hysterectomy and got on the plane. But many of us are dealing with situations that won't change anytime soon (or ever), even with three weeks of "aggressive rest." We have a life-altering medical issue in my family that we've been told, scientifically, can never be healed. It isn't my story to tell, so I won't give more details. Just know it stinks. Big-time. That's a different kind of acceptance of God as my "adequate resources." I've prayed for a miracle many times, but I live in the acceptance that God loves the one who is suffering and wants and promises the best (not easiest) for them. The beauty is that even amid a seemingly hopeless situation, I have hope because I trust God. No big profound words on that, just the truth that trusting Him is my peace. He is my "adequate resources."

As I decluttered my home, it became more peaceful. It improved aesthetically, but peace came because decluttering helped me know what I had. When every space was stuffed full, my overwhelmed brain had no idea what was in the piles. I lived with vague feelings that I might very well have the thing I needed, but I dreaded the hours I'd have to spend searching for it. The more I decluttered, the more I knew what I had and could handle what I had. I was conscious that my resources were adequate.

The more I know God, the more I relax in His loving sovereignty.

Physical Weakness, Spiritual Maturity

I turned fifty last year. I've probably peaked. A strange thing starts happening in your forties. Weakness happens. Eyes can't see the words on the menu. Gray hairs multiply. A lot of us start snoring. No matter how much I swore I'd never snore, I snore.

I used to have 20/16 vision. If you don't know, that's *better* than 20/20. But around the age of forty-two, I found myself working hard to see the words in my Bible. I'd been increasing the font size on my Kindle for about six months. I finally broke down and bought a pair of reading glasses. I was relieved to be able to read again but also low-key mad that after four decades of being proud I could read a sign a mile away, I was holding papers out as far as my arms could reach if I wasn't wearing my glasses.

It isn't a coincidence that both weakness and maturity come with age. When you are young, you aren't *completely* wrong to believe you have the agility, energy, and speed to get away from an animal chasing you in the woods. You might walk

through a dangerous area of the forest where a wild animal could probably take you down, but your confidence in your own strength convinces you you'll be okay. You don't stop to consider reality and risks. Think I'm making this up? I've had teenagers, y'all. Teenage *boys*. I also remember/experienced my own overconfidence.

There is a direct relationship between weakness and maturity. The flat-out inability to do something cancels out any delusions that you can do it. If you live long enough, you will grieve someone who didn't assess their own weakness and vincibility correctly. As my son's doctor said when he turned eighteen, "At your age, disease is pretty rare. Most life-altering or life-ending medical events at your age happen because of bad decisions."

For years, I didn't understand spiritual maturity. It felt ambiguous and difficult. I could recognize it in others, and I trusted their input because they seemed to view situations as God does. I wanted to be like that, but making a habit of studying the Bible scared me. I knew "good Christians" read the Bible and prayed at the same time every single morning, but my attempts at trying to do that had failed.

When I was invited to a hard-core Bible study, I was afraid. I loved God. I loved Jesus. I loved thinking about, talking about, and learning about God, but I was scared to study the Bible. It felt like it would be a lot of work, and that was overwhelming. I was smack-dab in the middle of my Mom Brain years. I was busy dealing with preschoolers. Studying didn't appeal to me. Homework frightened me. I really wanted my kids to be part of the children's program I'd heard so much about, though, so I decided to suffer through for their sake. I planned on enrolling

my kids in the program and coasting through my own Bible study part.

Much to my own surprise, I fell deeply in love with studying the Bible. Through reading the Bible on an almost daily basis, I changed. I began to think differently, understand differently, and react differently. I was maturing spiritually.

I learned that spiritual maturity is not a test we study to pass. It's not something we can achieve. Spiritual maturity is what happens when we trust the Holy Spirit to give us understanding of God's Word and show us how to apply that understanding in our lives. Studying the Bible was never supposed to be memorizing a bunch of facts. It wasn't academic. The Holy Spirit wants to work in us, through God's Word, to give us understanding. It's not about me deciphering the meaning. Spiritual maturity is given to us by God. The Holy Spirit does the work, not us (1 Corinthians 2:12).

When I started studying the Bible as a nonacademic endeavor, reading God's Word almost every day, I experienced how the Holy Spirit works. I saw how mind-bogglingly applicable what I was reading in the Bible was to my life in the moment when I was reading it. As I learned more about God and how He works, I was able to relax. I saw the purpose of my weakness and the absolute pointlessness of my efforts at control. As I allowed the Holy Spirit to work in me, I matured spiritually.

God Is in Control

My level of spiritual maturity is the level of control I've given over to the Holy Spirit. It's the opposite of an achievement. It's

knowing and accepting the truth that anything I understand, I understand only because God's Holy Spirit gave me that understanding. First Corinthians 2 is an excellent chapter to read on this subject, especially verses 12–13: "What we have received is not the spirit of the world, but the Spirit who is from God, so that we may understand what God has freely given us. This is what we speak, not in words taught us by human wisdom but in words taught by the Spirit, explaining spiritual realities with Spirit-taught words."

The week before I wrote this chapter, I came across one of my very favorite examples of God using weakness for His purpose. In the New Testament book of Hebrews, Paul talked about the role Jesus plays as High Priest, giving us access to God the Father. He talked about Jesus being the be-all and end-all Priest because He is God. He is eternal and He is perfect. Sinless.

But Jesus also understands weakness. Hebrews 4:15 says, "For we do not have a high priest who is unable to empathize with our weaknesses, but we have one who has been tempted in every way, just as we are—yet he did not sin." This is part of the value of priests, and it's why seeing Jesus as our Priest reminds us that He understands our struggles. Hebrews 5:2 says a priest is "able to deal gently with those who are ignorant and are going astray, since he himself is subject to weakness."

There's purpose in the human weakness of the priests. God-designed weakness. That weakness gives them the ability to relate. To deal gently with others who are weak. Jesus is God incarnate. God in the flesh. This was so He could die for our sins but also so He could deal gently with us. He knows what it's like to be human. I have come to understand this in a deeper way as I've come to accept that God created me to teach overwhelmed

people how to declutter. I understand the need because I understand the pain. I understand the bewilderment, and I understand the excuses.

Again and again, I hear that my understanding of people's excuses is the reason they can trust and follow my advice. Like Tammy said in a review of *How to Manage Your Home Without Losing Your Mind*, "There are so many things she brings up in her book that have come straight out of my mouth and mind (especially when it comes to excuses)." Or Catrina's review: "This book truly eliminates the excuses and gives you the practical steps to get out from under without the guilt." The power of being understood can't be underestimated. I'm no priest, but God designed my weakness for this purpose.

Saying "God-designed weakness" might give you the heebie-jeebies. I get it. Please feel free to dive into Scripture to prove me wrong. In 2 Corinthians 12:7, Paul wrote, "Therefore, in order to keep me from becoming conceited, I was given a thorn in my flesh, a messenger of Satan, to torment me." No one knows what Paul's thorn was, though many have guessed. We each have a thorn. Something we wish or pray would go away. Something embarrassing or frustrating or painful. My natural bent toward debilitating disorganization of physical stuff is my thorn.

Paul was given a thorn in his flesh, a real and ongoing struggle, that he referred to as "a messenger of Satan." And yes, I believe his thorn, his weakness, was God-designed. I believe it was God who gave him the thorn because Paul stated that the purpose of that thorn was to keep him from becoming conceited. To prevent pride. That thorn continually reminded Paul of his inability to be self-sufficient. God's answer to Paul's plea that this thorn be taken away was (in red letters, so it's Jesus talking):

"My grace is sufficient for you, for my power is made perfect in weakness" (verse 9).

Since this thorn was given to Paul for the purpose of preventing the sin of conceit, I believe God gave him the thorn. Satan seeks to lead us into sin, pushing the buttons of the struggle. But the struggle, the weakness, isn't the sin. Our weakness isn't a design flaw; it's the actual design. We were designed to need God. Needing God is not the result of sin. Sin is the result of thinking we don't need God.

Spiritual maturity comes from accepting that we can do nothing on our own. God has already accomplished everything that needs to be accomplished. We have the conscious possession of adequate resources because we have Jesus. We have peace because we trust God.

God isn't asking the vast majority of you to go public about your messy houses or your panic attacks or your feelings of failure or whatever weakness you try to hide. But He *is* asking you to give Him your heart. To trust Him fully and completely with your weakness, to not expect Him to "take it away" but to do with it as He sees fit. To heal you or cure you or not. Maybe He'll use your weakness as a way to help you depend on Him more than you would if life were easy and smooth all the time. Maybe He'll use it to give you compassion for others who struggle. Maybe He'll use it as a way for you to encourage someone else that they aren't alone.

Chapter 10

"How I'm Made" Versus "Just the Way I Am"

I tend to get a few reactions from people when they find out the name of my blog and podcast: *A Slob Comes Clean*. Some assume I'm super organized now. Super-duper organized enough to tell the rest of the world how to get super-duper organized too. I think this comes from considering what it would take for them to be willing to do what I do. They'd admit something so shameful only if they'd completely conquered it.

Others assume I love being a slob. People who live in messy houses *must* just like living in messy houses, right? They assume my goal is to justify and celebrate being a slob.

At this point in the book, you know neither of those things is true. Accepting myself didn't mean I gave up on my house. Self-acceptance made change possible. Accepting that my brain works differently from the brains of naturally organized people was crucial to finally transforming my home. Not just helpful but *crucial*. It was singularly the most important part of my entire deslobification process.

People Like Me are idealists. We want to do the very best

135

thing in the very best way so we can get the very best results. Most of us would like everyone to be happy, and we'd love to contribute to that happiness. This outlook on life has a lot to do with our houses becoming Disaster Zones.

One of our biggest problems (and loveliest qualities) is that we tend to not see limits. We jump into doing the very best thing in the very best way, without considering there might be limits to our time, energy, or capability. We collect stuff for the crazy, cool possibilities of the person we might be in the future—crafty, resourceful, handy, generous, and always available in someone's time of need. We don't consider the limitations of the space we have available in our homes or the limitations of our ability to keep stuff under control.

I've made up a lot of decluttering terms, two of which I'll share in this chapter. Understanding these reality-based concepts helped me finally find the balance between who I am and what I need to do in my home. The definitions I'm sharing in this book will be brief, but there is a *lot* more to explore. (If you want to know more, the terms have their own chapters in *Decluttering at the Speed of Life*.)

To be clear, these aren't decluttering strategies I made up. They are decluttering truths I identified. They're facts put into words that make sense to People Like Me. Because they're facts, the spiritual imagery is fairly easy to see.

The Container Concept

Contrary to what I once assumed, the purpose of a container isn't to hold things. Containers (such as baskets, tubs, and bins)

are meant to serve as limits. If your attempts to get organized consistently end in frustration and bewilderment, there's a pretty good chance you are not using containers as limits. It's hard not to say more here (because there's so much more to say), but if your solution to having more crayons than will fit in your crayon bucket is to buy three more buckets, you're not using containers correctly.

The simple (though not obvious at all for People Like Me) answer is to let the first bucket be the limit. (I want to say so much more because this is a "change everything" concept, but you'll just have to grab the other book. Sorry.)

Clutter Threshold

My Clutter Threshold is the point at which I have more stuff than I, personally, can handle. Each person's Clutter Threshold is different. Different Clutter Thresholds are why my neighbor (or my mother) could have the exact same stuff in the exact same space, and hers would stay neatly arranged but mine would look like the aftermath of a natural disaster. Because I have a low Clutter Threshold, I need to have less stuff if I'm going to be able to keep my home under control, no matter how much I like stuff and wish I could have more.

Accept Reality

The most important common thread between these two concepts—the Container Concept and the Clutter Threshold—is

acceptance of reality. Accepting that I can't have as much stuff in my house as my mother can have in hers is accepting the way I'm made. It's accepting that I'm different from her and that being different from her is okay. The world would be a boring place if we all looked and acted and operated in the exact same way. But when it comes to me being different from the way I wish I were, it can be kind of a hard pill to swallow.

Accepting the size of your house as a limit to how much stuff you're able to keep can also feel frustrating. What if your current home isn't the home you want? What if you have a fairly realistic five-year plan to remodel? Or move? What if you desperately want a Karl Farbman–sized chest of drawers, but your bedroom is small and you have to shop at IKEA? I understand the frustration and the resistance. But I can tell you, accepting the reality about yourself and the reality of your space leads to freedom.

When People Like Me don't acknowledge our unique realities (our Clutter Thresholds), we do things like block the back door with bags upon bags of things to give away, carefully sorted according to who would be most delighted to receive what's inside. Our intentions are noble, but our realities are maddening. We trip over the bags. We set reminders on our phones to take them with us the next time we might see the person who might want them. But we ignore the reminders, forgetting to connect with our intended recipients again and again until the pile of bags becomes part of the landscape. Eventually, they topple. We start using a different door.

We save and collect supplies for any craft project our local preschool might want to do in the future. We give up our dining rooms for Girl Scout Cookie season or coat drives or to collect diapers for someone in need. We accept hand-me-downs that

won't fit our kids for at least three years, even though our closets are already overstuffed.

That's what is so hard about accepting reality. Acceptance means changing the way we operate, which can feel like giving up on a dream. But on the other side of the very real pain of accepting reality is the gift of freedom. Decluttering decisions are no longer angsty. Bargains aren't (as) irresistible. We can keep the boxes of Samoas and Do-si-dos organized because we're not spread too thin (with rooms packed too full) by the thirty other noble projects we're collecting things for. Accepting the reality of our brains and our spaces is how we win the hopeless battle.

Freedom in Boundaries

Boundaries provide freedom. My answers to most of the decluttering questions I'm asked start with the phrase, "Well, it all comes down to the Container Concept." Understanding that space is finite is crucial. There's no way to get (or stay) organized if I deny this fact.

The beauty of the Container Concept is that I don't have to figure out the boundary. I just have to acknowledge it. Whether I like that boundary or not, staying within it is the only way to have the home I want. That's a fact. Wishing it wasn't a fact has no impact on its factuality.

Limits sound restrictive, but the opposite is true. When I kept every last thing with no consideration for the physical limits of my space, I couldn't enjoy living in my home. Accepting boundaries brought me the freedom I'd always wanted. I was able to live in a home that didn't feel cramped and overwhelming. I could

find what I needed at the moment I needed it. I could live the life I'd dreamed of when I was collecting all that stuff.

The spiritual truth reflected in this physical truth—that limits are actually freeing—is that accepting reality means accepting how I was created by a loving God who designed me to need Him desperately. Facts are facts. I am me, and I'm not self-sufficient. Even if I can make enough money to pay for the shelter and food and clothing I need, ultimately, I'm not self-sufficient. If eternity starts now, the only thing I have to hold on to is God.

Accepting reality, accepting boundaries, leads to ultimate freedom. I don't have to build or create my own reality; that's already been done by Jesus. I'm free from that burden, pressure, and anxiety. I don't get to make up how this all should work, but also, I don't *have to* make up how this all should work. That's a relief. That's faith.

I love the way someone in a Bible study group I attended defined *faith*: "Faith is abandoning all trust in my own resources." There's freedom in accepting the reality that nothing I do can get me closer to God. The coinciding truth is that I owe Him everything—all of me—because He made a way that doesn't depend on me. This truth means my life looks different. Selfishness and pride cannot be my guiding reality. Belonging to Jesus means selfishness and pride have no space to exist within my identity in Christ. They simply don't fit.

When I make decisions about whether something is container-worthy, I'm asking myself, *Does it deserve space in my home?* In my spiritual life, the question is, *Does this deserve space in my heart? Does it fit in the identity Jesus has given me?*

Not that I don't end up with more skillets than I need sometimes. I can't resist buying a good one at a garage sale for a

dollar. Or my kid brings one home from his college apartment and it makes its way into my kitchen cabinet. Or my mother-in-law finds one for me at Ross that's just like the one she loves. "Suddenly," I've got a collection of skillets shoved in sideways, and the cabinet door won't close.

Falling back into a pattern of sin is easy. I justify selfish decisions amid a busy season of life. I pretend I don't see the text when a friend asks if she can stop by to borrow my Crock-Pot. I speak less than kindly to my kid, whose mess irritates me more than my own mess irritates me. But when we realize our spaces or our lives are out of whack, we're reminded again that we haven't been living within those beautiful boundaries, and the things that need to go become clear.

It's all about function. Does this physical item get in the way of our space functioning well? Does this thing (generally a sin) we're holding on to for dear life make it harder to function in our relationship with God and in the world? The more we live within the freedom of boundaries, the more excited we'll be to *keep* living in them.

The Gray Areas

I teach to declutter down to the limits of the container first because the container (any finite space) is a clear boundary, and acknowledging a boundary makes every decluttering decision easier. I don't have to decide if I like or dislike an item; I just have to blame the container. I'd love to keep it, but I can't. It doesn't fit.

The Clutter Threshold is a little harder to grasp because it is personal. Your Clutter Threshold is the amount of stuff you,

personally, can easily keep under control. If your space regularly gets out of control, even though the stuff in it technically fits within the boundaries, it has too much stuff in it. Declutter and then declutter again until it's easy for *you* to keep it under control.

Spiritually, this is the stuff that may not technically be a sin, but it's more than I can handle. It's stuff that would be fine for some people, but it might lead me into sin. Certain social media accounts might be fun follows for other people, but they cause me to feel jealous and discontent with my life. Following those accounts isn't a sin, but if following them leads me into sin, I need to let them go. Commitments are great, but when I say yes to too many, I shut down and can't fulfill any of them well. Sometimes I realize a show I've been enjoying is starting to make me think unkind thoughts, so I need to stop watching it. These things aren't necessarily sins, but I have to let them go to keep myself from straying toward sin.

Lowest Common Clutter Threshold

Most people's favorite reason for not having the home they want is because the other people living there are the problem. They complain that these Other People have irrational attachments to their stuff. The Other People don't care what the house looks like. Basically, having a perfect home would be easy if they lived alone.

Or more honestly, *Why can't everyone just do things the way I want them done?*

Or even more honestly, *Why can't everyone just be exactly like me?*

My advice is to declutter common areas to the lowest Clutter Threshold of the people who use that space. If everyone in the family uses the office supply cabinet on a regular basis, using a complicated system that works great for Mom but is well above the Clutter Threshold of the twelve-year-old is a losing battle. Less stuff is the answer, even if Mom would be able to keep everything organized were she the only one using the space. But if she wants the space to stay under control, she needs to accept the reality that each family member is unique. She can make as complicated a system as she wants to organize her own spaces, but she needs to implement the lowest common Clutter Threshold for family-shared areas.

The spiritual parallel? Just because I *can* do something doesn't mean I *should* do it. I need to put aside my freedom for the sake of another person who isn't able to handle what I'm able to handle.

A lot of 1 Corinthians talks about this. In chapter 8, Paul addressed an issue that the Corinthian church was having about eating food that had been sacrificed to idols. He first stated that idols aren't real: "An idol is nothing at all in the world" (verse 4). And he confirmed that the only true god is God: "Yet for us there is but one God, the Father" (verse 6). So, technically, eating food that had been placed in front of an idol was like eating food that had been placed in front of a hammer. Or a coffee maker. The issue was irrelevant. *Technically.*

But, as verses 7–9 say, "Not everyone possesses this knowledge. Some people are still so accustomed to idols that when they eat sacrificial food they think of it as having been sacrificed to a god, and since their conscience is weak, it is defiled. But food does not bring us near to God; we are no worse if we do not eat,

and no better if we do. Be careful, however, that the exercise of your rights does not become a stumbling block to the weak."

And then there's verse 13: "Therefore, if what I eat causes my brother or sister to fall into sin, I will never eat meat again, so that I will not cause them to fall."

Get that? I'm free to eat whatever I want, but I need to put my freedom aside for the sake of others. God could have zapped Adam and Eve when they sinned and then started all over again. But He didn't. He wanted that relationship with them—still. Even after they'd messed up. His love for them didn't change, even if the way the relationship looked had to change.

My way might be perfectly fine, but if it causes harm to another person, I need to give up my way. Doing things my way doesn't bring me any closer to God, but it might confuse someone else and end up hurting their relationship with God.

My way of organizing a space might very well be more photo-worthy. While I might wish that the other people in my house could handle my complicated (and picture-perfect) system, I choose to give it up for them. I let go of my way for the sake of our relationship. This lets me demonstrate that I accept them as God created them. Their inability to arrange paint bottles by size, brand, and shade isn't a character flaw, even though I can't imagine *not* doing it that way. I give up "my way" to help us all be successful and functional in our home.

When I give up my preference, I show someone else—in a tangible way—that my preference isn't more important than our relationship. Breaking that relationship could mean becoming unable to help them with an issue that matters way more than paint bottles. I give up my preferences to keep a nonissue from turning into an issue.

I don't have many opportunities to give up eating meat that was placed before idols. But living with other people gives me plenty of opportunities to give up my pride for the sake of putting another person's needs first.

The One-In, One-Out Rule

Once I hit my Clutter Threshold, I was able to keep my home under control. But I didn't know this threshold was a thing until I hit it. I was just decluttering (and decluttering and decluttering some more) until one day, I looked around my house and realized it wasn't overwhelming to me anymore.

As someone who attracts clutter more than the average person, I realized that in order to *stay* under my Clutter Threshold, I had to practice the One-In, One-Out Rule. That means if something new comes into my home, something else needs to leave for me to maintain the decluttering progress I've made.

Swapping the Good Stuff for the Best Stuff

I started writing about my messy house only because I was so desperate to start writing. I had lots of ideas about what I could write, but ultimately, they all boiled down to intentional living. I'm passionate about being intentional with my time, my words, my family, my relationships. I was always mind-boggled when I spoke to someone who didn't think as much as I did about living with purpose. Yet at the same time, my house was a disaster. My home didn't reflect my passion for intentionality, and I knew

that, but I didn't understand where the disconnect was. Now I get it.

There's a limit to the number of great ideas I can act on, no matter how many come flying into my head on a random Tuesday. My house, my time, and my ability are all limited.

For three decades of my life, I couldn't/didn't read the Bible consistently. The incredibly short version of what changed is that I made it a priority. I'm someone who had heard a version of "You just have to make it a priority!" a bajillion times. I would always ask, "But what does that meeeeeaaaaan?"

The One-In, One-Out Rule is how you maintain your Clutter Threshold, but it also applies to other areas of your life. When I finally, purposefully fit (almost) daily Bible reading into my life, I gave it a specific time and removed something else from my day to make room for it. Just wanting to read the Bible wasn't enough. I had to create a space for it in my day. I was motivated to do this because I saw how much more the other women in my Bible study discussion group were getting out of the same study because they were consistent. They worked on the study all through the week instead of frantically cramming the night before.

I remember feeling frustrated that I "couldn't" study the Bible the way the other women in my group did. I *explained* to God that I didn't have time in my schedule, that there was simply no room. My explanation-prayer was soon answered. (God's like that.) Soon after I prayed, I realized the time I was spending on the internet each morning while I drank my coffee could instead be spent reading my Bible.

I responded, "But I love that time drinking my coffee!" *I'm embarrassing like that.* Every day, I looked forward to coming

home after dropping my oldest kid off at school and having a little "me time." I perused coupon deals and read interesting stories online while my younger two kids watched a show on Disney Jr.

But I did it. I replaced something perfectly fine with something better. I couldn't do both. I accepted reality, and I ended up much better off. Soon, I started looking forward to reading my Bible. I had a natural reminder (coffee!) that the time had arrived, and studying the Bible became as important and regular to me as I'd always wanted it to be.

Accept Yourself the Way God Made You

Accepting limits is freeing. If I have space to keep four things, but I keep eighty-four things, I can't use any of those eighty-four things. They are stuffed in tight, hard to find, and difficult to access. All the things end up wasted, and I feel overwhelmed. But getting rid of eighty of those things allows me to enjoy, appreciate, and use the four things that are left. Accepting the realities of the space I actually had—not the space I *wished* I had—changed my home. When I stopped wishing for a bigger house, I could finally appreciate the house I had.

Accepting the realities of the brain God created in me isn't giving up. Admitting I am not someone who naturally straightens and color coordinates and rearranges isn't giving up. It's freedom to stop doing what doesn't work for me and discover what does work for the brain I was given.

Do I wish I had the awareness of random stuff leaving my hands in random places at random times? Of course! But doing a

five-minute daily pickup is more far more effective than wishing I could be someone else.

I'd love to be focused enough to read the Bible and get so absorbed in its words that nothing would distract me, but God made me hilariously distractible. So I do what I've figured out (through trial and error) works for me: I go to the same spot every day with my coffee, my Bible, a pen, and a study guide with questions that keep me on track. I leave my phone in another room. I jot things down on a running to-do list if something unrelated pops into my head while I'm studying. (When I don't do that, I can't concentrate because I'm worried I'll forget something.)

I wish I were disciplined enough to not need all these boundaries, but I'm not. Wishing I was different never accomplished anything. Accepting what I need to do to be successful means I'm able to do the thing I want to do. Accepting the limitations of my brain isn't giving up.

Accepting myself the way God made me isn't an excuse to leave the dishes undone or the closets in shambles or my Bible unread. Accepting myself the way God made me means I let go of the good ideas so I have the capacity to spend time and energy on the great ones. Accepting myself the way God made me means I can live intentionally.

Freedom in Christ

In John 8:36, Jesus explained that "if the Son [Jesus] sets you free, you will be free indeed." True freedom to live in joy, with clarity, and in your purpose comes from knowing Jesus. Accepting the reality that Jesus is God and I am not means I'm given His

righteousness and therefore can have a relationship with the Creator of the universe. Accepting this changes me. I want to live a holy life, not out of fear or in an attempt to control my own destiny but out of freedom. I'm fundamentally different than I was before. Sin no longer fits because the Holy Spirit now lives in me.

What If You Feel Too Far Gone?

I can't end this chapter without addressing those of you who fear there's no hope for your home. You've tried "everything" and nothing has changed. If that's you, it's possible the spiritual parallels cause skepticism too.

I understand. With each failed attempt to get my home under control, I grew more and more hopeless that it could ever happen. Accepting reality about myself and my home was my turning point, but change was far from instantaneous.

Salvation works the same way. It's a moment of acceptance that gives us freedom but a lifetime of growing and learning what it means to live in that freedom.

Let's talk for a moment about how we can truly know that something is an answer to a prayer—like when I prayed to God about finding time to read my Bible. This prayer-and-answer situation is a good example of how, often, my prayers are answered with new understanding. In my situation, the prayer came first. I was confident God's answer would be, "You're right, Dana, you *do* have too much going on." But I did ask. I truly didn't see any time gaps in my day that could be spent reading my Bible. (The One-In, One-Out Rule wasn't something I understood yet.)

A short time (hours? days?) after I prayed that prayer, I had a moment of realization, of understanding. Out of "nowhere," it hit me that I was spending time on something unnecessary while thinking I had no time for something I knew was necessary. The clear solution came to me, and my reaction was to groan, probably audibly. I did not want to give up that part of my day, that "me time" I'd carved out for myself.

The answer to my prayer wasn't what I wanted to hear or what I wanted to do. At the same time, I knew God's answer was right. His answer was a direct solution to the "impossible situation" I'd named in the prayer, and it lined up perfectly with what I knew God wanted from me (and for me). Honestly, the fact that I wasn't excited about the obvious and right solution gave me confidence that the answer was coming from God and not from my own desires.

This is just one small example of how my prayers have been answered, time and time again. It's never fun to feel that initial groan coming out, but I can testify that God's answer is always (like, *always always*) better than my way. The absolute joy, peace, and confidence I've experienced through consistently reading God's Word is so much better and more satisfying than any of the amazing deals on spaghetti sauce I probably missed.

Chapter 11

(Don't) Deny Reality

Embracing reality does not come naturally to me. My last year in college, as the fun was ending and we were forced to think about real life, I would often cry out, "Deny reality!" I didn't want to think about how my friends and I wouldn't be spending every waking hour together, painting sets and learning lines and making each other laugh until we cried. I lived in denial that we were going our separate ways all over the country. I forbade anyone from talking about these realities that threatened to make me sad. I forced my friends to solemnly promise that every single May, for the rest of our lives, we would take a trip together. Making things go the way I wanted them to go was pretty much my whole personality.

Maturity comes from accepting that reality doesn't always happen the way we think it should or wish it would. Our choice is to adjust or fail. Doing things the way we wish they could be done, even though that way doesn't work for us, is futile. It's frustrating. We had a few years of "May Trips," but then some of us got married, a few had kids, and none of us had the disposable income we assumed we'd always have to spend on trips together.

Every few years, we try to find a way to connect, and I've had to make the decision to be grateful for those moments instead of resentful over the ones that didn't happen.

I admit I tend to overuse the word *frustrated*. It feels like a nicer word than *mad* or *ticked*, but it also lets me blame the thing (or the person) that's frustrating me. My mother-in-law loved to tell the story of a conversation she had with my oldest son when he was four. She'd called on a random weekday to talk to him. My morning as a mom of young kids hadn't been easy, and I was thankful for the distraction of her phone call. When she asked my son what he and his brother were up to, he said, "Oh, we're just being frustrating."

I get frustrated when things don't go the way I think they should. I rock in-my-head scenarios. I can spout long lists of reasons how and why something should work. But ~~sometimes~~ many times, things don't work the way my logic says they should. Sometimes my scenario wouldn't work for anyone, ever, and sometimes it just wouldn't work for me.

Different Minds, Different Methods

Here's one way this plays out in my house. On paper, my No-Mess Decluttering Method (the only way decluttering has ever worked for me) doesn't look like the very best way to declutter. Most experts say the first step of a decluttering project is to pull everything out of a space. Dump it all in a box, drag it into the hallway, or stack it on the counter above the drawer you're tackling. In an ideal world, with no interruptions or distractions, that is excellent advice. For a person who can't rest until every single

item has a home, the pull-it-all-out method is great. But then there's me. I'm guaranteed to get distracted at some point before I'm done, and my brain is more than happy to forget about my decluttering project until I trip over the mess two days later.

Here's how I used to "deny reality" while working on my home: I'd fail at the expert-recommended, pull-everything-out decluttering strategy. I'd try it again, then fail again. I'd think it through, plan it out, send the kids to Grandma's house, grit my teeth, and give it another go. With the first try, I had hope. The second try was harder, and the third try demanded intense mental gymnastics because I knew I was going to fail again. In my desperation to declutter, I kept hoping the next time might be different. But it never was. Eventually, I stopped trying. The mess got worse. I felt hopeless.

I finally made real progress in actual reality when I stopped denying how things worked in my home and in my brain. I accepted that I would always get distracted or run out of emotional gas in the middle of a decluttering project. Making a final decision on one item at a time and acting on each final decision as I removed each item from the space *worked*. I make real progress every single time I declutter this way, even when (not *if*) I stop in the middle of the project. On paper and in hypothetical scenarios, my way feels less efficient. But the "most efficient" way didn't work for me, so it wasn't actually efficient at all.

The Danger of Denying Spiritual Reality

I'm as capable of denying spiritual reality as I am of denying any kind of physical reality. I used to wait for a big, emotional sign

before I decided to make a change in my life. I wanted a singular, dramatic experience I could look back on so I could clearly mark the moment of transition from Me Before to Me After.

My No-Mess Decluttering Method leads me to slow but sustainable decluttering progress. In much the same way, slow realizations about who I am in relationship to God lead me to spiritual maturity.

When I attend a retreat or conference, I love to listen to riveting speakers. I hear principles from the Bible explained in ways that have never occurred to me. I love going to these events because they lead to big spiritual breakthroughs. At any conference, whether professional or spiritual, my goal is to pick one thing (at least) to implement. I was at a women's conference in 2011 when God made it clear to me that the "practice blog" I'd started two years earlier wasn't preparing me for another ministry—it was *the* ministry He had planned for me all along. God uses those big moments.

But those big moments don't take the place of my everyday relationship with Jesus. I've had more spiritual breakthroughs, more *oh-my-word-how-do-these-words-written-thousands-of-years-ago-apply-directly-to-what-I'm-going-through-today?* moments while reading the Bible and drinking my coffee on a Monday morning. I studied 1 Corinthians in depth in the year following that conference. I have vivid memories of reading my Bible at my dining room table and staring off into space as I absorbed the words. It was in that daily study that I saw again and again, in passage after passage, that God was always looking at my heart and not my messy countertops.

God uses speakers and authors to help me understand things, but God also wants to show me things Himself. Day after

day after day. Because I meet with a discussion group to talk about the things I study on my own, I get to hear how God uses the same words to speak into different hearts in different ways. That's why the Word of God is called "alive and active" (Hebrews 4:12). That's why the Holy Spirit is so powerful. He brings the Scripture to life.

In the anxiety-ridden year of 2020, I had my first kid graduating from high school and heading to college. My daily time spent reading and studying the book of Genesis got me through. While many verses in the Bible directly address anxiety, my biggest help in that time came from learning more about who God is and has always been. I saw His sovereignty and His love played out in the lives of people who were experiencing much worse things than being stuck at home and missing out on life as we'd assumed it would go. My perspective of time changed when I read the accounts of God resolving hard situations over the course of decades even though I wished He would resolve mine in less than a week.

Day by day, God's Word gives me what I need. I learn things I need that day. The next day, I learn something (or am reminded of something) that helps me through *that* day. Each moment like this builds my trust in Jesus and deepens my relationship with Him. These days add together to form months and years and even decades of God directly working in me and my life. This changes me. This grows me.

Big, pizzazzy Whole Room Decluttering Projects are great. Shocking "before and after" photos can inspire. Occasionally, I move my home forward by leaps and bounds in a single weekend, but that's never a substitute for work done daily. Waiting for a free weekend is not better than taking five minutes on a

Thursday morning to work through the first two steps of my decluttering process and achieve "less" in my entryway. Five minutes seems like nothing compared to the shebang of a weekend with "nothing to do but declutter," but ultimately, the regular baby steps move my home forward more than the shebangs ever have.

Waiting backfires. Waiting for shebangs means living in denial for longer. Waiting allows the struggles, frustrations, and random bags of garage sale purchases to build up. And as they build up, they become more and more overwhelming. This puts excessive pressure on the upcoming Big Project and makes it harder for the shebang to have the depth of impact I need it to have. The Big Project turns into a Bigger Project, which requires more mental energy to start and physical energy to finish. The piles of clutter are bigger and more daunting.

Experiencing this physical phenomenon in my decluttering efforts helps me better understand the parallel spiritual truth. When it comes to spiritual matters, I experience the impact of doing a little whenever I can. I see the dramatic effect of not waiting for a dramatic moment. My relationship with Jesus is much stronger when I make it a priority to spend everyday moments with Him than when I wait until I hear a powerful word shared by someone else.

Facing Failure

There are two kinds of Decluttering Regret. The first kind is the What-If-I-Need-This-Someday Regret. There's also Keeping Regret. That happens when you realize you kept something so

long it was wasted. I've experienced both, and I can say for sure that Keeping Regret is worse.

When I'm decluttering, I come across items that are physical proof of failure. Maybe, five years ago, I purchased a can of specialty paint for 80 percent off. I planned to use it to transform the table in my entryway. I find the paint completely dried up, lost and forgotten at the bottom of a pile in the garage. My big success (finding a great deal) turned into a failure. I didn't save 80 percent; I wasted 100 percent of the money I spent. The table looks just like it did before. (Or maybe I got rid of the table three years ago.) Now I have to deal with the dried-up can of paint.

I've had more experiences like this than I care to count. Fear of facing more failure can make me avoid decluttering. If I can ignore something, leave it closed up in a drawer, I can pretend it doesn't exist. I get to maintain my delusion that I'm doing just fine. If I start digging through a pile, though, there's a good possibility I'll feel some icky feelings. I prefer to avoid feeling icky feelings, so I look away from the pile. As long as I don't see what's in it, I don't have to face my failure.

Spiritually, facing failure can look like this: If I ignore hard questions, difficult issues, and tough circumstances, I get to keep pretending everything is okay. I can convince myself that walking with Jesus means general happiness and increased chances of success in life. But ultimately, that hurts me when bad things happen and I can't keep pretending anymore.

There comes a point when pretending isn't possible. Denial isn't possible. I can't find the remote because clutter swallowed it whole, and Super Bowl Sunday turns into a stressful event for my football-obsessed kid. A friend who has experienced terrible pain gives up on God because she believes He hasn't heard her prayers.

Had I decluttered back in December, maybe the remote wouldn't have disappeared. I could have been open and honest with my friend about my own struggles so she would have felt the freedom to talk to me about her doubts before she decided to turn her back on her faith. I could have shared the hard things in my own life and the peace that comes from God even amid the pain and frustration and uncertainty.

Stages of Growth

In the Bible, God uses the image of aging to help us understand the stages of spiritual growth. Or, more specifically, He created us to age with the purpose of aging as an image. As humans, we don't just observe growth; we *experience* growth. In 1 Corinthians 3, 1 Peter 2, and Hebrews 5, the ability to digest milk versus solid food is used as an image to show the increasing ability to truly understand and embrace sometimes-difficult-to-understand spiritual concepts.

The ways we eat at different stages of life show the progression of how believers grow in their understanding of Scripture. Infants drink milk. They have to be fed by someone else and can eat only what's easily taken in and digested. Toddlers can bring food from the table (or the floor) to their mouths, but they don't know where to find food or what is safe to eat. Older kids can scramble their own eggs but generally don't have the resources or knowledge to purchase or grow what they need for a well-balanced diet.

Then there are teenagers. Honestly, I love this age. Teenagers can do all of it. They're big enough to plan, shop for, and cook

an entire meal on their own. They're even old enough to earn the money to pay for it. There isn't much an adult can do that a teenager can't, except for having the resources or freedom to do it. But as any mama knows, despite what her sixteen-year-old (who has absolutely *everything* figured out) believes in his adult-sized heart, teenagers aren't quite ready to do it all on their own. Sometimes they have to, but that's in a less-than-ideal situation. Ideally, a teenager can exercise independence with guidance from an adult who loves her more than life itself.

Teenagers are at a good place in their gastronomical journeys. Most don't have those weird after-forty intestinal issues yet, but their palates have matured to enjoy more than chicken nuggets. One of my own teenagers once decided he was going to "eat with an open mind." He declared that because my husband and I don't like raw tomatoes or onions, his palate had been *ruined*. He complained that he'd "never even been given the opportunity" to expand his palate. He started ordering meals at restaurants exactly as they came, with no adjustments. When I asked him if he realized he'd ordered something on rye bread (which I dislike) with tomatoes and onions (which I can't stand), he told me to stop treating him like a baby. He was right. (Also, if my kid wants to rebel by eating more vegetables, I win at parenting.)

My point is that teenagers are supposed to be a little difficult. They're supposed to start making their own decisions. They're supposed to start thinking things through. They need to stop assuming everything they heard as a child was absolute truth. Not because those things aren't true but because truth won't affect or transform their lives if they don't understand it for themselves. They need to ask questions. Hebrews 5:13–14 says, "Anyone who lives on milk, being still an infant, is not

acquainted with the teaching about righteousness. But solid food is for the mature, who by constant use have trained themselves to distinguish good from evil." They are actively transitioning into maturity, into understanding. If you're in the teenager stage with your faith right now, that's okay. It's a natural step of spiritual maturity. So ask those questions.

God created us and our phases of aging to help us know Him more. In His Word, He gives us an image of growth, a picture of the phases every flesh-and-blood human goes through, to help us understand how our relationship with Him grows. We go from being told what the Bible says to reading it ourselves, to examining it closely, and finally, to understanding it. And remember: True understanding comes only from the Holy Spirit anyway.

No experience in my life has tempted me to deny reality more than parenting. Not coincidentally, parenting has also taught me that any control over circumstances or other people that I ever thought I had was a delusion. Thankfully, God has also taught me that since He is in control, I can rest in that. God is the perfect parent I will never be. He can handle any question. No question scares Him or makes Him stammer with defensiveness. He knows the heart and the anguish and the hurt behind the concerns you have, and He can handle your questions.

Don't deny reality. It doesn't work. Don't buy the lie that accepting reality is giving up. Look for beauty and God's purpose in the situation and life He's placed you in, right now. He's reaching out to you in this very moment, ready to show you how much He loves you.

Chapter 12

So What (Exactly) Counts?

A I was writing this chapter (literally), my friend Jane called. She needed to decide whether she should go on a weeklong mission trip. The deposit was due, and she was suddenly questioning everything about it. She wanted to know if she'd really get to do things. Substantial, life-changing things to help people. Was she really needed? Was it going to be weird? She basically said the trip sounded like something she would really enjoy, but because it sounded so fun, she thought maybe she shouldn't go. I hear the same question from both people who want to declutter and Christians who want to do the right thing: *What counts?* What counts as decluttering? What counts as serving Jesus?

That First Step Is the Hardest (But Also the Most Important)

Decluttering Paralysis is a very real thing. Approximately 114 percent of My People have to break through it to start

making progress. Decluttering Paralysis happens when you feel so overwhelmed by the sheer volume of decisions that need to be made that you can't even start. It seems like every single one of those decisions will be emotionally difficult and potentially life-altering. Some people find it hard to catch a breath. Their heart rate accelerates.

Here's a spoiler if you haven't read any of my other books: My hard-learned advice is to start with the easiest of the easy stuff. Look for trash. Looking for trash gets you moving. Giving yourself permission to remove the most obvious, least emotionally volatile clutter helps you break through the paralysis and make immediate progress. It might be just a teeny-tiny bit of progress, but it's progress.

There are, of course, more steps in my decluttering process, and they're designed to take you all the way from totally overwhelmed to a space that's free of excess stuff. But that very first step? It counts. That first step is *real* decluttering, just as much as the final step that makes you call your family into the room and say, "Ta-da!"

If the first step doesn't happen, none of the other steps can happen. For so many years, I believed it was pointless to spend five minutes throwing away trash when the pile of randomness loomed three feet high. The pile grew. I grew more overwhelmed.

But taking that first step is vital. Seeing value in doing small things lets you eventually accomplish big things. I had to stop questioning the validity of what I was doing. I had to stop worrying about knowing how everything would end before I even started. I had to stop waiting to begin until I was sure I had the time and resources to make things perfect.

We need to talk about perfectionism here. A lot of people like

to blame their messy houses on perfectionism. Yes, the fear of not doing something perfectly can keep you from doing anything at all. I understand, and if it helps you to think that way, go ahead. I couldn't blame my messy house on perfectionism though.

I am a true perfectionist in some areas. With those things, I can't stop working until there's absolutely nothing left to do, and then I work some more. I experience an unexplainable internal drive to make a play or a book exactly what I envision it could be. I have never felt that way about my house, though, so I don't call my house issues perfectionism. But I've definitely experienced a sense of pointlessness in trying when I know I can't (or don't trust myself to) finish something.

I'm glad the world contains people who don't need to be told to start with the trash. But a whole lot of us *do* need to know it's okay to start with trash, and we need someone to tell us it's okay. I'd only ever heard decluttering advice from the people who didn't know some people need to hear that throwing away trash is the first step. It's okay to take that first step and be proud of that first step.

The Little Things Matter

There are some pretty amazing and dramatic faith stories out there in the world. Listening to them gets me totally jazzed. Sometimes, those of us with less-dramatic faith stories can hear these amazing and dramatic testimonies and wonder if maybe our faith isn't as real.

Maybe we served on a mission trip but the experience wasn't nearly as challenging as we'd imagined it would be. Maybe we

have a bunch of kids and can't find the time to form a complete thought, much less speak eloquently to a crowd. Maybe we've always lived in the same small town, where nothing big ever seems to happen. The idea that doing small things in boring places doesn't matter can paralyze us from taking any action. Not seeing the point in doing something seemingly mundane and undramatic can cause us to do nothing at all. If it's not big and showy, is it even worth it?

Some of my most meaningful spiritual experiences have come in the form of a meal brought to me by a friend (love in a soup pot). Small things done when opportunity and resources collide add up to big impact. I write books about *cleaning*. Like, the actual most unexciting topic ever. I started out sharing pictures of my own messy closets and writing down my own irrational thoughts. For years, I argued that what I was doing was just practice for the thing God *really* had for me to do. The big thing.

I was wrong. The little thing, writing about something as boring as cleaning, was the thing God had for me. I've received thousands of messages from women who tell me my blatherings about dirty dishes and clutter were direct answers to their desperate prayers. They thank me for making the boring subject of cleaning a little less boring. They thank me for this ministry, which is really just me doing the thing God asked me to do, even though I didn't know why He'd asked me to do it.

What counts as following Jesus? Doing whatever He asks you to do. Today. Right now. Whether that's answering kindly when the new cashier at the grocery store looks like he might cry because you handed him a coupon, or adding an extra two dollars to your restaurant tip because you feel like God wants you

to, even though you have no idea whether the server needs an extra two dollars. Maybe it's meeting a friend for lunch at a nice restaurant or at the park with tuna salad sandwiches. Big crowds aren't always where it's at. You're not what everyone needs, but someone needs you.

Embrace Your Microniche

When people ask me how I achieved success, first of all, I'm pretty sure they think I'm more successful than I really am. But I'll share what I believe is the biggest factor: I've embraced my microniche. Marketing experts encourage you to find your niche, the spot where you can best impact a specific group of people. Don't worry about reaching everyone, or you'll appeal to no one.

I feel like I've taken this whole embracing-your-niche thing a step further. I don't just share cleaning and decluttering strategies; I share cleaning and decluttering strategies for people who don't like cleaning and decluttering. Not just people who don't like it, but people who struggle. Not just people who struggle, but people who feel like complete failures. People who feel absolutely hopeless and bewildered by every other cleaning and decluttering strategy they've tried.

If I gave only "typical" decluttering advice and showed pictures of beautifully decluttered spaces, I might have a lot more followers—but I wouldn't be helping the people who desperately need what I have to give. I wouldn't be embracing my microniche.

For every Billy Graham who has a publicly recognized ministry reaching millions of people, there are thousands who sit

next to someone in church and make that one person feel less alone. Feeling less lonely helps that person relax so they're ready to hear the truth of who Jesus is and how much He loves them. The person who rocks a baby in the nursery is serving God. That baby's parents can go to a Bible study knowing their daughter is being loved and cared for. The person who washes the tablecloths after a church dinner is serving God. It all matters.

The woman who sits next to someone who almost didn't come to church because she was so worried no one would talk to her? She's just as important as Billy Graham. Smiling counts as serving Jesus. Really.

Knowing God's Will

This is a tough one. I know because I have felt the angst, and often I still feel it when I ask God to show me what is next.

The founder of the camp where I learned how to clean had a huge impact on me as a teenager—so I'll default to what I heard him say many times about determining God's will for your life. Basically, don't overthink it. He didn't use those words, but he talked about how teenagers who want to serve God are usually looking for a sign, like a lightning storm that spells out "Move to India!"

His advice was to ask God to guide you and then do whatever God places in your heart to do. If you want to learn to play the guitar, learn to play the guitar. Follow the opportunities that come along that let you serve God by playing the guitar. If you want to start a blog, start a blog. If you want to teach a sewing class, teach a sewing class. Do the thing you're driven to do with

the goal of glorifying God, and He'll lead you to whatever He has for you to do from there.

So many people I know who started out blogging are now doing something else, but blogging was a step toward where they're serving God now. They wouldn't be where they are now had they not taken that first step.

As a "born performer," I feel I must address something here. This won't apply to more than half the people reading this book, but some of you need to hear this. (You can skip the next few paragraphs if the thought of auditioning for a play or singing a solo is as foreign to you as an obscure language spoken only in a country you've never heard of.)

Is it wrong to desire to be onstage? Is it wrong to seek out opportunities for your words to be read by more than a friend who opens an email? Is it wrong to want to sing outside of your shower?

I used to be a theatre arts teacher. From a young age, I was driven by something inside me to do theatre. I'd always had the desire and the dream, but before the ninth grade, I hadn't had much opportunity beyond acting in skits at church. In the spring of my freshman year at a teeny-tiny Christian high school, a teacher called a group of students to her room for a meeting about the yearly academic competitions that would begin at the high school level for our school's association. My older brother had competed, so I knew a little about it. She listed off math and current events and science competitions, and then she mentioned prose and poetry interpretation. She said something about how these were basically acting competitions.

I perked up. I wasn't interested in competing for any "who's the smartest?" prizes, but this was an opportunity to perform! I signed up to compete in those (and only those) events.

There was no one to coach me in our tiny school, so my ever-supportive mother called up an old friend who had majored in theatre and asked if she would help me get ready. We drove forty-five minutes to her house every week for a few months. I prepared, and I placed high enough in the regional competition to go to the state level, where I won second and third place in the two events. The desire I'd had my whole life had collided with opportunity, and as it turned out, I didn't stink at acting.

With this confirmation that I wasn't *completely* delusional, I moved to a different high school, one that had a theatre program. That led to doing theatre in college, which led to becoming a theatre teacher.

Life happened, and I quit my teaching job to become a stay-at-home mom (which was exactly what I wanted to be). Because I had real-life training and experience, I started directing church productions. For some reason I could never quite understand, the people I worked with at one church assumed I could (and would) also write scripts. After explaining that I could not, I did. That lit in me a passion for writing.

One desire acted on with prayer led to another desire acted on with prayer, and now you're reading this book. For a message to reach someone who desperately needs to hear it, someone else has to be willing to speak that message. Someone has to want to be heard.

Purpose in the Passion

The passions in your heart are full of purpose. I believe God designed me to be desperate enough to write that I was willing

to share publicly the thoughts that were my greatest source of shame. Had it not been for that desire to write, I wouldn't be doing what I'm doing right now.

Maybe you're not itching to write. Maybe you have no desire to speak into a microphone. I have to bring this up because I have talked to way too many people who believe that if they want to do something so badly, it can't be what God wants from them. It must be a selfish desire.

If they love applause, is that pride? Pride is bad. If they feel energized standing in front of a group of people and getting a belly laugh from the whole crowd, is that energy self-centered? Can it be godly to experience the adrenaline rush of joke after joke landing perfectly?

But that's what a comedian experiences. That's what drives her to get back onstage, even after a set that doesn't land. The drive is real, and I'm thankful for it. One of my children, after years of Sunday school lessons and talks with Mom and Dad, made the decision to follow Christ while listening to a Christian comedian who was legitimately funny. I'm thankful for all the time that guy spent practicing in his mirror, getting the punch lines just right. I know some might consider practicing jokes a waste of time, but they don't think laughing is a waste of time. Because a good performance seems effortless, they discount the time, practice, and effort required to make them laugh.

I also talk to a lot of people who want to do mission work. They want to travel and tell people about Jesus, but they hold back because travel is something that sounds fun and exciting. If it sounds fun and exciting, God couldn't possibly be prompting them to do it, could He? They tell themselves that their desire must be coming from a self-centered place. Meanwhile, people

who need to hear about Jesus aren't hearing about Jesus because the people who should be telling them about Jesus aren't pursuing their dreams.

Did you know God puts the desire to travel into your heart? I'm not saying everyone does it for the right reason, but if you are freaked out enough about your own motivations that you would consider not going just to be sure you don't go for the wrong reason, I'm guessing your motivations are pure.

Some women don't host the book club they desperately want to host or teach the Bible study they desperately want to teach because of the same fear. The project sounds too fun, so it couldn't possibly be spiritual enough. Some women don't reach out to invite another woman to lunch even though they are desperate to make a friend. Their own desperation feels selfish. This stuff can get real warped, real quick.

Good news: Jane decided to go on that mission trip. I like to think that my encouragement to appreciate the little ways she could be a blessing instead of worrying about not being a big enough blessing helped her make her decision. There's value in your serving God in some sort of way today and tomorrow and every day. He created you to meet a specific need that you might notice only after you get started. So get started and do something. Scratch your itch and get your blood flowing, and that action of actively seeking to serve God will lead you to what He has next for you.

Twenty-Year-Old, Brand-New Tires

M y family has a few phrases we repeat as inside jokes, and a lot of them came from my late father-in-law. "That's the way the bongo bingles" basically means "life happens." "If brains was gas, I couldn't back out of the garage" is fitting in situations where you just don't understand what's going on. I'm sure he grew up hearing those expressions in his own small-town Texas family.

Some of his phrases were original, though, and only our immediate family can grasp the meaning. Like: "Those are brand-new tires." Said with a little twang and a lot of insistence, that phrase can communicate a lot between my husband and me. It's best used when one of us insists we should keep something because it's valuable, even though everyone else can see it isn't.

Years ago, my husband wanted a boat. His dad let us have the one that had been sitting, mostly unused, in his shed for years. It was already an old boat when he'd bought it twenty years earlier.

171

(Here's a little fact about boats from my nonexpert perspective: They're kind of a hassle.) Even though the boat hadn't been used in years and my husband had to spray a special concoction into the engine to even start it, the boat's trailer had "brand-new tires." My father-in-law was very proud of those brand-new tires and mentioned them every single time he talked about the boat. We were happy to check trailer tires off our list of things to worry about.

But then the first tire blew. Then the next. And then the next. With the first blowout, we felt bewildered. But . . . but those were brand-new tires! Jack (my father-in-law) said so! Thirty-seven times last week! The second blowout made us suspicious, and when the third one blew while we were on our way to replace them all, we understood the truth.

The tires had been brand-new when my father-in-law paid good money for them at a reputable place. As a DIY guy who took pride in making things work for as long as possible, it wasn't easy for him to shell out cash for brand-new tires. But when we got the boat, they weren't brand-new anymore. They were at least twenty years old. In my father-in-law's mind, they were new because they were barely used. But barely used doesn't equal new.

While the tires sat unused through ridiculously hot Texas summers and varyingly cold winters, they got old. They grew hard and cracked, and even though they looked fine to our untrained eyes, they weren't. They couldn't function the way they'd been designed to function. They couldn't do what they could have done back in '89. They're a good reminder that things don't necessarily retain their usefulness just because they're not being used.

Saying the phrase "those are brand-new tires" makes us smile in memory of my father-in-law, but the words also encapsulate an important life truth: Storing stuff doesn't give that stuff value. On the contrary, storing stuff often robs it of value.

Shift Your Focus to Eternity

Every time I study a book of the Bible in depth, God shows me a theme that is woven throughout that book. Over the last several years of studies, a theme that has stood out to me again and again is "eternal perspective." Eternity is real, so we need to prioritize the things that are eternal. Their value lasts, and they're the only things that matter. That's why we need to make sure the temporary things don't crowd out the eternal things.

If you've read my other books or listened to my podcasts, you know how I feel about Keep Boxes. I used to love them. I had gazillions of those boxes sitting in my garage, full of stuff I wanted to keep but didn't have a place for. I didn't use the stuff in those boxes, and eventually I couldn't remember what was even in them. I started out thinking of those Keep Boxes as Boxes Full of Possibilities and eventually saw them as Boxes Full of Decisions I Dread Making. But Keep Boxes are actually Procrastination Boxes. Stuff that lives in a permanent state of possibility or procrastination isn't fulfilling a purpose. It isn't doing anything. But while it's not doing anything, it's also, often, losing its ability to do something someday.

In an ideal variation of the boat-trailer tire story, the boat would have been used, many times, over the life of those tires. They would have served their purpose by going up and down the

road, carrying the boat to its destination. But that's not the point of this chapter. The point of this chapter is the same as every other chapter in this book. The point is *Jesus.*

The rotting tires are evidence of value being placed on the wrong thing. The focus was on the past instead of the present. Or on possibilities instead of purpose. On what had already been done (researching and buying some good, solid tires) instead of the reality of the current situation (that the tires had grown old and rotted).

Matthew 6:19–21 is a Bible passage I learned as a kid. It has always felt very understandable and straightforward to me:

> Do not store up for yourselves treasures on earth, where moths and vermin destroy, and where thieves break in and steal. But store up for yourselves treasures in heaven, where moths and vermin do not destroy, and where thieves do not break in and steal. For where your treasure is, there your heart will be also.

I've heard this verse referenced as a decluttering prescription, but let's look at it in a different way. Stored stuff rots. That's fact. A stack of boxes creates dark little hidey-holes for bugs and mice, just by existing alongside other stuff that isn't being used. It's happened to me, and I've received countless emails from others who've experienced the same thing.

When we moved for my husband's job, our old house sat vacant for about six months. It was already a stressful time as we waited for it to sell, and then the Realtor called one day to tell me gophers had dug under the house and caused damage in one of the bathrooms. (At least that's what I remember

from two decades ago.) I was lamenting to my aunt about this terrible timing and our terrible luck. Why did this have to happen while we were gone and didn't know it was happening? She commented that if we'd been living there, it wouldn't have happened. The gophers moved in only because no one was living in the house. It's a fact. Critters like places and piles that aren't being actively used.

When stuff gets ruined because it sits unused, I feel guilty. Getting the heebie-jeebies upon finding *evidence* of vermin, learning the hard way that there are bugs who eat old books . . . These experiences produce intense regret.

Chapters 5–7 of Matthew are called the Sermon on the Mount. Matthew is the first book in the New Testament, and this sermon was the first major teaching of Jesus Matthew recorded. Jesus covered so many things in these red-letter words. He explained, He clarified, and He went deep. He went eternal. He began to shift His followers' thinking from the things they had always known—the aspects of life they could touch and feel and see—toward eternity.

The life application in Matthew 6:19–21 isn't a condemnation for clutter. It's a prescription for checking your heart and shifting your focus toward eternity. These are Jesus' words, and these verses cover one subject in a whole list of things He addressed concerning evaluating the heart and its motivation. Just before these three verses, He spoke about not praying for show, not fasting to make people think you're amazingly disciplined and committed, not making a big deal about giving to the poor to make yourself look good. Basically, He said to do everything for the right reason. And the right reason is always to glorify God, not to impress people.

All That Is Temporary

If you've ever had to work through clutter, if you've found mouse poo in the box of table linens you brought home from your grandmother's house, you get it. Jesus described a physical reality that we've all experienced in some way to help us understand a spiritual truth we all desperately need to know. He wanted us to understand something we can't see by using an example we can see. Jesus' words open our minds to the eternal perspective—the only one that actually matters.

Work through your clutter. Create a makeshift hazmat suit that will enable you to touch gross things if you need to. But don't think of these verses as proof that having Keep Boxes in your garage means you've failed to please God. As you go through the decluttering process, feeling frustrated with yourself when you find something that was ruined because you couldn't let it go, look for the value in that frustration. Understanding the value of my irritation in these kinds of moments had a big impact on truly changing my home for the better.

As long as a pile sat in the garage, as long as I didn't look closely at what was in the pile, I didn't have to feel ashamed about wasting something—but that didn't mean I wasn't feeling anything negative. I felt frustrated that the pile existed. I felt irritated every time I stubbed my toe on the trophy sticking out of the bottom of the pile. I couldn't park my car in the garage because the ding-dang pile was there. Those were nagging frustrations with no end in sight.

But when I worked my way through the pile, giving a few things homes and eliminating the rest, every smashed sombrero I unearthed that had to go into the trash changed me. Every

sombrero in the beachfront souvenir shop looked different to me on our next beach vacation. I saw every maraca, every huarache, and every painted conch for the future clutter it might be.

See your stored clutter for what it is: a physical example of the temporariness of life. Notice the dust because God created dirt and dust to help you differentiate between earthly stuff and eternal stuff. Stuff we can see and touch is temporary. Holding on to it doesn't help it hold its value. Vermin and rust and moths ruin stuff. That's a fact. It's science. Jesus chose this example because the experience is universal. The image illustrates that life as we know it is temporary and imperfect.

That "brand-new" tires rot while sitting unused is a physical reality that teaches an important spiritual truth. The deterioration that happens to physical stuff is designed to serve as a contrast to eternity. There's purpose in the nibbled paper or cobwebbed box because we get to see the truth that nothing physical lasts forever. And that helps us recognize what is eternal.

As you declutter, let your grossed-out-edness help you understand a greater truth. Allow each crumbling piece of paper, each warped-from-the-summer-heat plastic toy, each gnawed book corner, to do what it's designed to do: remind you of the difference between the world you currently live in and the promise of eternity.

People like to pretend they've never seen mouse poo in their homes. Most of them have. That's why Jesus used this example. He knew the understanding it would give. Deal with the poo, declutter what has been destroyed, and let go of the shame. Choose to be thankful for the personal lesson on the differences between here and heaven. When you get a little extra insight into what's coming, let that turn into a little extra hope.

Happily Sometimes After

When my son decided to take a gap-year mission trip around the world, I felt all the feelings a mom in my position would expect to feel. When I realized he had to pack everything (including a tent and a sleeping bag) into one hiking backpack and a small daypack, I got a little jazzed by the challenge.

As he was packing, he realized his beloved, very large Bible would take up more space than he had available, so I offered him my thin Bible. (Same words, just without additional study tools and maybe smaller print.) He casually took it. I smiled bravely to his face but cried the next morning when I used my husband's Bible. I missed my kid, but I ~~really~~ also missed my Bible. I'd had that Bible for years—transformational years in my spiritual journey. The underlines and tiny notes in the margins felt like a part of me. I knew the physical paper hadn't transformed me—the words had—but it was still painful. The struggle was worth it, though, because (dramatic pause) *my son needed my Bible.*

After he left, I made a stop at a Christian bookstore (not simple since the closest one is almost an hour away). I wanted to

touch and feel and hopefully bond with a new Bible. I found one I liked and brought it home. At first, I still missed my old Bible with its crunchy-from-coffee-spills pages and rubbed leather cover. But the new one . . . had *two* ribbons. The Bible study I'd just begun involved a lot of flipping back and forth, so having two ribbons was nice. Also, the new Bible was my favorite color. I kind of loved it.

I'd given up something I loved for the sake of my kid going to tell people about Jesus, but I wasn't suffering quite as hard as I'd thought I would. My story was still dramatic though. I'd sacrificed my beloved Bible for a meaningful cause. I'd cried about it and everything, y'all.

Then my son texted. His training in the US was coming to an end, and he was heading overseas. He'd packed and repacked and figured out what he could live without. He decided the big Bible was worth the space and weight. I mailed him his Bible, and he mailed mine back to me.

Well, that was anticlimactic. All my sacrifice was for nothing. My great story of giving up my beloved Bible was significantly less dramatic then. To further diminish the drama, I decided to . . . keep using the new one. I mean, it had *two ribbons*!

This ended up being kind of a nonstory. I like stories (mine especially) to have big moments and powerful endings. I had sacrificed my *Bible*. For my *son*. For a *mission trip*. If you're going to give up your Bible, that's pretty much the very best way to do it, right? I was letting it go so it could go do great things!

I used to want all my decluttering stories to have satisfying endings. Unfortunately, my desire for the stuff I didn't want in my own home to go do great things in its next life brought my decluttering progress to a grinding halt. When I stopped to

worry about where my stuff was going, if I focused on creating a powerful ending for my crap, the stuff sat in my home for way too long.

My castoffs continued cluttering my house while I obsessed over getting them to the very most perfectest places where they'd be appreciated and loved. Often they sat in the garage until they ended up dusty, unappealing, and forgotten.

Sometimes I had great ideas about where my clutter should go, but the people I thought would be excited to take it didn't want it. Or I kept forgetting to take my kids' hand-me-downs to them, and their kids outgrew them too.

More significant than other people missing out on my junk, though, is the part about the junk staying in my house. My house was out of control, well over my Clutter Threshold. I was desperate to declutter. Creating different piles of things to go to their perfect, appreciative homes felt like decluttering, but my house wasn't getting any easier to manage. Actually, it was getting worse. What had once been shoved into my kids' closets was now stacked in the hallway, on the guest bed, or on the dining room table. Those stacks were highly likely to topple or get shoved back into the closet at the sound of a doorbell.

Then there was the three-ton example. When we bought a car, we chose not to trade in our old Chevy Suburban because we envisioned being heroes to someone who could really use it and appreciate it. They would be incredibly grateful to us and probably go on and on about how thoughtful and generous we were. Maybe they'd even cry a little.

That gargantuan thing sat in our driveway until it died completely on one of our infrequent rides in it. Our only option to get rid of the Suburban without spending money to fix it first

was donating it to an organization that would tow it away. We'd never know what happened to it.

Controlling the Narrative Stops the Story

My desire to turn my clutter into satisfying stories always features myself as the hero. But that desire is unrealistic, and it usually backfires.

So what's the spiritual parallel here? How do we get from an old Chevy Suburban to Jesus?

My life as a follower of Jesus is not transactional. My obedience to God comes out of my identity as His child. His Holy Spirit living in me means I desire to do what's right. I don't obey to ensure a satisfying ending in this life. I can follow Jesus, pray every day, and strive to live in holiness, but bad things will still happen. Christians get cancer. A Christian's home can burn to the ground just as easily as the home of someone who doesn't love Jesus. My best friend at work can get moved to a different department with a different lunch schedule.

As believers, we're not promised an easy life and most definitely not a life the world would consider safe. But we are promised God. We are promised a relationship with Him and the peace that comes with that relationship. God's peace changes what we want out of life. It also changes how we look at every situation in our lives.

In John 9, when Jesus healed a man who had been blind his whole life, people wanted Jesus to tell them why this man had been blind from birth. Who had sinned? The man or his parents? Jesus answered, "Neither this man nor his parents sinned . . . but

this happened so that the works of God might be displayed in him" (verse 3).

I sometimes find myself wanting to exchange my obedience for a guaranteed result. I'll pray for direction, but I'll add to that prayer: *Please let me know exactly where each path will end up if I come to a fork in the road.*

God's Word is a lamp unto my feet, but it isn't a crystal ball. I can see what to do now, in this moment, but I can't know where I'll end up. If I'm unwilling to move forward until I know how it will all end, I'm stuck never moving.

When I follow Jesus, I can move forward in obedience even though I don't know how God will use that obedience or where He'll take me. I literally, in my wildest dreams, could not have pictured myself teaching people all over the world how to declutter. I'm thankful I said yes when God told me to "write about that," even though I had no idea what He had planned.

I'm not promised a happy ending here on earth, but I am promised that in every situation, God will be with me. That means even the unhappy "endings" have value if they help me know Him more.

The Struggle Is Real

Another reality of (my) life is that even when get-it-all-the-way-out decluttering happens, new clutter appears. Again and again and again.

Someone who had cheered me on when I first started my deslobification process told me she couldn't read my blog anymore because it irritated her when I showed a decluttering

project in a space I'd already decluttered before. That is the exact opposite of a helpful or endearing thing to say to someone like me, but I get it. The transformation is unsatisfying because the work is not done—like, *forever* done. I want to live in the after-photo moment forever, but that isn't reality. And it especially isn't reality for People Like Me.

How does this physical reality help me understand spiritual truth?

The struggle continues. A moment of surrender is powerful, but it doesn't always eliminate all future struggle. Even if a solved problem doesn't reappear, that problem will be replaced with a new one. The physical reality of reappearing clutter is the image of a spiritual truth. Those of us who get to experience this truth more than others are just being given an extra dose of understanding.

In Romans 7:15, Paul reminded us of an incredibly frustrating reality: "I do not understand what I do. For what I want to do I do not do, but what I hate I do." He went on to say, "I find this law at work: Although I want to do good, evil is right there with me. For in my inner being I delight in God's law; but I see another law at work in me, waging war against the law of my mind and making me a prisoner of the law of sin at work within me" (verses 21–23).

Paul got it. He understood the power of God and understood what God wanted from him, but it's hard, y'all. So hard. And the reality of sin means we don't do it right all the time just because we understand what to do. This struggle exists because we live in an imperfect world. We know God has already delivered us through Jesus, but the reality of sin is a constant struggle.

I know what it takes to have a home that runs smoothly, but sometimes I look up to see the recliner piled with Amazon

packages again. On the floor beside the chair are the photo boxes someone went through and didn't put back in the cabinet. I have to take a deep breath and remind myself—again—to start with trash. I know truth. I know what to do, but I mess up. Those aren't sins; they're just the facts of living in a home with stuff coming in and life being lived.

Whether because of outside circumstances or not paying attention or a busy week or a moment of purposefully deciding to ignore it, getting behind on things happens. The existence of the struggle doesn't negate what is true or mean I don't know what is true. It's just a struggle.

And the very real, in-my-face struggle of keeping my home under control is a gift if I let it remind me of my life as a follower of Jesus. Perfection isn't something we can achieve anyway, but we keep trying. And instead of letting that reality dishearten me to the point of giving up, I let it be a reminder to rest in what God has already done. Why do I think I have to continue striving to achieve the holiness He's already given me? I didn't accept the truth about holiness being from Jesus so I could finally do it on my own. It was so I could stop doing it on my own. And so I remind myself of who I am and who He is—and that the relationship between those two things is all that actually matters.

As I put the photos back in the cabinet, I remember my situation *isn't* the way it was before. This time, I need to deal with only a few things. Every time I retackle the space, it stays under control a little longer, and I'm a little more likely to catch myself before dumping something on that recliner.

I examine the situation I find myself in again—the one I thought I'd surrendered to God. I'm infinitely better for having already given my life to Jesus, and I just need to move forward

again. Pray. Identify what needs to go. Remind myself of what's right.

Re-decluttering is a thing. Before I started this deslobification journey, I didn't know it was a thing. Realizing I'll never actually be finished means I don't have to feel like a failure when I go back and tackle a space a year after I first tackled it. I just have to re-declutter. Every time I re-declutter, some of the things I held on to so tightly the previous time are now easy to let go.

It feels like bad news when individual victories aren't the ending that lets us coast, but it's good news that mistakes aren't the ending either. The Bible is full of people doing the wrong things. They make mistakes, often big ones—from accidentally doing the less-than-ideal thing to purposefully choosing the glaringly wrong sin. Jacob and his mom tricked his brother out of an inheritance. Peter cut off a guy's ear. Joseph's brothers threw him down a well and told their dad he was dead.

I have heard from thousands of people who tell me their real hope from reading about my deslobification journey comes from seeing that I kept messing up and still kept going. They gain hope from seeing that a kitchen counter piled with dirty dishes (after months of not going to bed without doing the dishes) isn't the end. It's not all over. It just means you have to do the dishes again.

When we don't talk about the mess-ups, we leave everyone else (who is messing up, because literally everyone messes up) thinking their mess-ups are the end of their story. They feel their mess-ups are proof that they can't do this. Whatever they understood or accepted or implemented didn't work, so there isn't any hope for them. In reality, though, it's just a mess-up. And we can keep going, because that's the only option in this new identity. We're different.

My favorite biblical example of God's desire for us to keep going even when we mess up is in Genesis 3. After Adam and Eve chose not to trust that God had their best interest in mind when He told them not to eat from a specific tree, God explained what their choice meant. But then "the Lord God made garments of skin for Adam and his wife and clothed them" (verse 21).

Adam and Eve had been walking around in the buff. They were out there, loving every minute of it! Unencumbered by itchy waistbands and unaware there could be such thing as a wedgie. But when they sinned, they realized they were naked and were embarrassed about it.

God's plan was for Adam and Eve and all of us to live without sin. To be free and happy and unashamed. This was God's desire; it was the ideal. Then Adam and Eve made a choice they immediately regretted and consequently felt shame and the need to hide. They no longer lived in that free and happy and unashamed ideal world, but God made them clothes. He dealt with the reality of the situation, even though He didn't cause the situation and had given them everything they needed, including clear and specific warnings to avoid it.

But God dealt with it. He didn't toss Adam and Eve aside. He didn't smite them and start over. He made them clothes. He handled the situation and kept going.

Also, clearly, laundry is the direct result of sin.

Enjoying God's Provision, Right Now

I've experienced the gift of having all delusions of control stripped from me (see also: being a parent of adult children). I've

learned (and forgotten and relearned) to appreciate each moment of God's provision for what it is in that moment. I resist the temptation to create destined-for-disappointment expectations of what something could mean for the future.

I'm a person who needs friends. My mother loves to tell how with every new phase of life I entered, my big fear (before changing schools, before going to camp, before starting a job) was always, without fail, that I wouldn't have any friends. "What if no one likes me?"

We moved to a small town six months before my oldest was born. When no one but our parents (who drove a few hours) visited us in the hospital for his birth, we had to accept that friend-making hadn't been going so well. We'd been looking for a church and just couldn't find one where we felt connected. We prayed for friends. We desperately needed them. God answered that prayer in a Taco Bueno.

Taco Bueno was our favorite fast-food restaurant because we could eat there for less than ten dollars, and money was tight as we adjusted to living without my paycheck. One Sunday after visiting a church where no one had spoken to us, a woman behind us in line at Taco Bueno said, "Oh, hi! It's so good to see y'all!"

She quickly realized she'd mistaken us for a different couple who had visited her church that morning, but that got us talking about church. She and her husband, who ended up sitting with us to eat our tacos and party burritos, invited us to their church. Specifically, to their eight A.M. Bible study class. We'd never heard of *anything* starting at eight A.M. at a church, but we were desperate enough for friends to get up and go the next Sunday. In that small group who showed up at church before most people had gotten out of bed, our new friends welcomed us.

Our prayer had been answered, and I imagined our kids growing up together and giving speeches at parties about how it all began in a Taco Bueno.

And then, just a few months after we'd met, they moved. I was devastated. I felt like the answer to my prayer for friends had been ripped away and tossed into the garbage. The lovely story of my prayer being answered in an unexpected place didn't make me feel thankful anymore. Instead, I felt betrayed.

But God worked through the twist of the story. When these welcoming people moved away, others stepped up and took on leadership roles within that class. My husband (the best Bible study teacher I've ever had) started teaching the class. We found our place. That gave us purpose and friends who shared that purpose (the best kind of friends).

When God answers a prayer or provides a breakthrough, my job is to be thankful for that answer or that breakthrough. My job is not to start imagining how that answer or breakthrough might lead to something even better down the road. If I do this, I can end up feeling let down, and the moment of provision won't be quite as lovely in my memory as it should be. Instead of reminding me of God's faithfulness, it brings up feelings of disappointment.

When my kids were babies and toddlers, I was at the height of my garage sale addiction. I used literal spare change to clothe my children in designer outfits I found in other people's driveways. I not only bought their clothes (and toys) for quarters but also sold them for way more than quarters on eBay *after* my kids had worn them.

This hobby was fun, but it meant every last thing I bought for my kids wasn't just something to enjoy. It was something to enjoy

and then sell. I couldn't enjoy anything to its fullest because I was always (at least subconsciously) thinking about how much I could sell it for later. Things couldn't simply be blessings; they also had to be opportunities.

So much of my decluttering success has come from a commitment to prioritizing my Right-Now Life. Being prepared for the future and respectful of the past has value, but my present was suffering because I was letting all that get out of whack. The present is the only time we're guaranteed. Decluttering forced me to admit I'd kept things I never needed for years while they made life harder to live in our home.

The spiritual application? Living out the physical truth that not prioritizing space and energy for today made life harder helped me understand the parallel spiritual truth better. Matthew 6:34 says, "Therefore do not worry about tomorrow, for tomorrow will worry about itself. Each day has enough trouble of its own."

If my closet has enough space for only one winter coat, the winter coat that fits and keeps my kid warm right now is the one that stays. The one that's super cute but slightly too small needs to go. The one that's three sizes too big needs to go. Even the high-end designer coat I got for $9.99 at the thrift store needs to go if it's too warm to wear in Texas, even on our coldest week of the year. I might love it. I might want it. But there's room for only one coat.

My Right-Now Life is the priority. And while thinking about the future is wise, it isn't wise if it's at the expense of living well right now. That's when preparedness morphs into "worrying about tomorrow." If I can't find the good coat because it's piled under and behind the iffy coats (and a few life jackets), my "preparation" has come at the expense of real life.

Experiencing this physical reality helps me see my spiritual

life differently. There's room for dreaming, and there's room for examining the past—but not at the expense of acting on what God has for me to do right now.

God Always Provides

Two years ago, I threw a decade's worth of Bible study materials in the trash.

Each May for ten years, I placed that year's completed study on the top shelf in my closet. That's where I would look for them (my first decluttering question), and I had space for them there (the Container Concept). When I packed up my closet to move to a new house, I had to decide if I was going to move those Bible study materials. Everything looks different when you move. Every item has to earn its space in the moving box.

Those Bible studies had huge value in my life. I'd kept them because they'd impacted me so much. So many of my transformational moments were scribbled on their pages. I'd never even questioned keeping them, because I assumed I'd eventually go back and revisit them to look for those nuggets of wisdom.

When we moved, I took the opportunity to finally act on what God had been nudging me toward for several years. I'd never gone back to look for those prior spiritual insights I'd scribbled down because God kept doing new things in my heart and mind. The value of those Bible studies wasn't ever in the paper but rather in the transformation God was continually doing in me. He'd hidden His Word in my heart through those studies. I'd learned to trust that He would continue to do that again and again and again.

There was nothing wrong with me keeping those old Bible study materials, but letting them go was an opportunity to act on what God had been teaching me. The act's real value was helping me learn to trust that God would be with me always, in every new situation and phase, with everything I needed.

I mentioned earlier in the book that my favorite definition of *faith* came from a friend in a Bible study. Here's her definition again: "Faith is abandoning all trust in my own resources." I'll also remind you of my favorite definition of *peace*, which came from a Bible Study Fellowship lesson: "the conscious possession of adequate resources."

As a stuff-gatherer, I don't think it's a coincidence that the definitions of *faith* and *peace* that cut right into my heart both include the word *resources*. I love the definition of *faith* because it feels like something I can "do." I can actively abandon. I can identify where I'm improperly holding tight to my own resources of strength, understanding, or ingenuity. And then I can open my hands and let these things go.

All the transformation that happened over those ten years of Bible study came from God. Not from me. Not from the papers I read or the notes I wrote. I can let go of those things and trust He'll continue to be the resource I need.

In the years since this big purge, I (almost) immediately let go of each Bible study as soon as it's over. It always hurts a little, but it also gets me excited about what's to come. I'm actively abandoning trust in my own resources so I can fully trust in God to provide what I need when I need it. This physical act helps me experience the spiritual truth. It's an opportunity to take real action. It's an opportunity to let go so my hands are free and I can hold on to God.

Chapter 15

Logs, Specks, and Cheese Stains

*E*very single time I speak to people who are new to my methods, I get some version of this question: "What do I do when it's my husband's (or kid's or roommate's) stuff that's the problem?" When someone gets inspired to declutter, their mind immediately goes toward the other person who *really* needs to learn this stuff. They want to change their home, but they often identify their biggest obstacle as the other people who live with them.

I get it. Other people's stuff drives me more bananas than my own stuff. There's a little room connected to my and my husband's bedroom. It isn't a room any guests would ever run across, and it doesn't have a specific identity other than what it might be one day (such as an office space for my husband when he eventually retires). We stuck his boxes of collector's items in there when we moved three years ago, and as of this moment, those boxes are still there, unopened. When our bedroom was painted, I shoved

more stuff in that room. But when I walk in there to deal with the aftermath of the shoving, guess what I want to get out of there first? Not my own suitcase or stretchy pants lying on the floor, but his boxes. The boxes at the edge of the room irritate me more than my own stuff because they aren't my things.

The third step in my decluttering process is removing the Duh Donations. They're obvious and easy and nonemotional, no decluttering questions needed. They can go straight into the Donate Box. Unfortunately, though, when people hear they're supposed to get the most obvious stuff out, they look at their spouse's (or roommate's or kid's) stuff and consider *that* the easiest stuff to declutter. It's obvious why *that* stuff needs to go. It's easy to feel zero emotional angst about getting rid of someone else's junk.

But when the other person resists the declutterer's sudden desire to purge *their* stuff, the determined declutterer despairs. Momentum stops, and all hope is gone. This other person just won't let go of what oh-so-obviously needs to go, and that's the problem.

I hear some version of this story again and again and again. I don't believe one single person who has asked, "How do I get other people in my house to let go of their stuff?" has been happy to hear my answer. I always say, "Declutter your own stuff and neutral stuff first. Your house will improve and you'll function better in it, even if they never declutter their stuff. But usually (no guarantee), the improvement they see in the home will eventually inspire them to loosen their grip on their own stuff too."

Sometimes I say, "It's easy to see other people's stuff as clutter, but when you fixate on their stuff and ignore your own piles, that's offensive and causes them to hold on tighter to their stuff."

And sometimes I think (and occasionally say), "It is self-centered and rude to criticize the other person while pretending you have no clutter yourself."

One of the biggest gifts of God's slow miracle in me was that I was forced to focus on what I, alone, was doing and not doing. For more than a month, I didn't tell my husband that I had started writing on the internet about trying to get our house under control. I was forced to pay attention to my own actions and avoidances and excuses. I saw the impact of what I did and didn't do.

My house immediately changed for the better when I started by doing the dishes instead of starting by trying to get my family on board. I can go on and on (and have gone on and on) about the impact of this mindset shift toward focusing on what I can actually do instead of focusing on how impossible it is to make other people do what I think they should do.

We're Not Always the Heroes

In Matthew 7:3–5, Jesus said,

> Why do you look at the speck of sawdust in your brother's eye and pay no attention to the plank in your own eye? How can you say to your brother, 'Let me take the speck out of your eye,' when all the time there is a plank in your own eye? You hypocrite, first take the plank out of your own eye, and then you will see clearly to remove the speck from your brother's eye.

These are red-letter words in my Bible because Jesus spoke them. If Jesus said them, I want to pay special attention.

Remember how fun it was to hear Jesus call the religious leaders "hypocrites" when they made a huge deal about His disciples eating without washing their hands? In this situation, though, *I'm* the one being called a hypocrite. That's significantly less fun.

My frustration over my family not letting go of their stuff brings out the hypocrite in me. It's the most normal thing in the world to see other people's clutter as obvious and easy but my own as complicated and impossible. The point is not that I'm shockingly hypocritical but that hypocrisy is the default for all of us.

The same thing happens to me in church. I hear a particularly convicting sermon and immediately think of other people who really need to hear it before (or instead of) looking at myself and my own sin. Other people's "issues" will always be more clearly visible to me than my own. Jesus addressed the tendency because it's a tendency I need to address in myself. Ignoring my own sin while pointing out sin in other people is harmful to me because my ignored sin affects my relationship with God. Ignoring keeps me from living in freedom from it. Ignoring my own sin while pointing out sin in other people is harmful to God's kingdom because people (rightfully) don't want to hear truth from people who are clearly lying to themselves. And if I'm representing God to them, I'm skewing their view of Him by being a hypocrite—and Jesus was clear that He had no patience for hypocrites.

Yay for the "opportunity" of a clutter situation to teach me that hypocrisy is such an easy thing to fall into. I get to see, in physical form, how it doesn't help the situation at all to focus on the wrong thing. As I start by decluttering my own things first,

I get an in-my-face understanding of the many things I need to work on. Jesus made this statement about specks and logs because the concept applies to every single person, and especially to me. It's human nature to identify what's wrong in someone else's action or attitude while being blind to what's wrong in my own actions or attitude. Identifying how it plays out in the physical world of decluttering helps me be more realistic and sensitive to where I'm being a hypocrite in other areas.

For most of my life, I identified with the heroes of Bible stories. What if I had to build an ark like Noah? What if God called me to do something big for Him, which meant being judged and misunderstood like Mary, the mother of Jesus? Of course I'd climb a tree like Zacchaeus just to see Jesus!

But a few years ago, while studying the book of Matthew, the Holy Spirit began to open my eyes to the truth that I should also be paying attention to the "bad" guys. When I read about the religious leaders rejecting Jesus because they were scared of what it would mean to accept Him, I related to that. A lot. The religious leaders were petrified of losing their own power and position and money and lifestyle. They didn't like the idea of life as they knew it—as they'd studied and trained and committed to living it—changing completely. They had control issues, just like I have control issues.

They were convinced they'd been doing the right things for the right reasons. Yet when they were confronted with truth, they couldn't identify truth as truth because it didn't line up with the way they thought things were supposed to be. With the way they'd been teaching others that prophecy would be fulfilled. In that resistance, they ultimately rejected the very God they thought they were following.

Am I willing to follow Jesus even if following Him means everything in my life could change?

In the verses about planks and specks, Jesus is talking to the hypocrite. He's talking to me. To you. We're all walking around with eye logs that need removing, and we all need Jesus to remind us those logs are there. When my own log has been in my eye for a long time, I've gotten used to it. I've adapted to seeing around the log. Sometimes the log bugs me, but in general, I pay no attention to it. Life is harder because there's a log in my eye, but I can't really remember what life was like pre-log. The harder-ness doesn't register.

Most of all, I know the *story* of *my* log. I remember back when it was an itty-bitty speck and how it didn't really seem worth taking the time to get it out. The speck grew into a splinter, then a twig, then a stick, affecting my vision more and more as it grew. Now it's been in my eye for so long that I barely even think about it.

My own clutter has a story. A history. An explanation. I'm exhausted just thinking about it. I dread feeling all those feelings I know I'll have to feel when I remember the reasons I gathered this stuff in the first place. And so it's much easier to fixate on my husband's clutter. I can see clearly that the shirt he wore when he won the Ping-Pong tournament on New Year's Eve in 1993 needs to go. No one wears sleeves like that anymore, and there's a cheese stain on the back. The *back*, y'all.

But maybe he remembers that he met me that night. He thought I was cute and wondered if I thought he was cute in that shirt. The sleeves are irrelevant to the memory. He's always planned to wear that shirt again, if only he could figure out a trick for getting out thirty-year-old cheese stains.

Most likely, all that is in his subconscious. He hasn't put

together why he feels panicky at the thought of throwing that shirt in the trash. He just knows he feels panicky. My cocked hips and flared nostrils don't help, so he holds on more tightly. He resents that I'm fixated on this shirt when, behind me, sits a dusty pile of fabric scraps I collected six years ago to make a quilt I never made because I have no idea how to make a quilt.

If I feel like I'm in the right when everyone else is wrong, I need to examine my own self for my own sin. I'm responsible for me, and I truly cannot help others without dealing with my own issues first.

This common decluttering challenge is a gift. It's a smack-dab, in-your-face example of how Jesus was talking directly to us: *Focus on yourself first. Focus on what you're doing and what you're not doing.* Doing this, I've learned from experience, makes an actual impact on my home, my life, and my spiritual health.

Helping Others When You're Not Perfect

"You hypocrite, first take the plank out of your own eye, and then you will see clearly to remove the speck from your brother's eye" (Matthew 7:5).

Waiting on or wishing for my own perfection can be a fantastic excuse for not helping someone else. For this reason, I resisted teaching this stuff even though people were begging me to teach them to do what I was doing in those first years of my blog. I didn't see how anyone would want to learn from *me*, and I was so paranoid about being a hypocrite that I decided I'd rather withhold the help I could give than risk someone assuming I had it all together when I most definitely did (and do) not.

But as I worked on my own plank removal, I learned what it took to remove a big ol' piece of wood from a little ol' eye. I experienced firsthand the impossible, the awkward, the uncomfortable, and the downright painful of it. Now, I see much more clearly what it takes to remove planks than I would had I never had a plank. I know the work, I know the pain, and I know the effort and time involved.

I'm thankful that the height of blogging was the unique time when I started writing. It was a great way to practice writing and find my voice by seeing what resonated with the people reading my blog. The fact that I was writing about working in my own home, figuring out what did and didn't work for me, meant I was focused on myself. But even when writing about my own feelings and experiences, my tendency—as it is for many writers—is to shift into the "understood you." For example, it's easy to pontificate about doing the dishes by saying things like, "When you have a busy night with three kids in three different activities and you're exhausted by the time you get home, sometimes it literally does not even cross your mind that the sink is full of dirty dishes."

That's a natural way to speak. I know I'm talking about myself, and technically, the reader knows that too. But I learned quickly that people's reaction to the sentence above was very different from the reaction when I wrote it this way: "When I have a busy night with three kids in three different activities and I'm exhausted by the time I get home, sometimes it literally does not even cross my mind that the sink is full of dirty dishes."

Same sentence. Same meaning. Very different visceral reaction from the reader. When I shared what I was experiencing and resisting and feeling, speaking only for myself by using *I* and

my, people commented in solidarity. They related. They shared lots of "Oh, my word, I'm exactly the same way!" responses. When I said the exact same stuff but used *you* and *your*, many fewer said, "Me too." Some were offended and needed to let me know that they absolutely did *not* relate. Over the years, some people have shared that when they first started reading my stuff, they weren't ready to admit the significance of their struggle with clutter. Reading as an observer (as I fully admitted my own struggles) helped them understand themselves. My honesty about myself helped them be honest with themselves. My honesty was more impactful than what felt like having their faults pointed out.

When I used *I* and *my*, people related and learned. When I used *you* and *your*, they didn't. Watching me remove the log from my eye helped. The same exact words written in a way that made them feel like I was pointing out specks did not.

What log needs to be removed from your eye? Acknowledging it and digging it out isn't fun, but living without a log in your eye feels amazing. And being honest about it goes much further in helping other people who watch you get it out than ignoring it. Even if they never get out their speck, you'll get to live log-free.

When It's Jesus at the Door

*O*ver the years of writing about my home, I've talked about doors and doorbells and knocking and opening a lot. Mentioning that my heart palpitates at the sound of an unexpected doorbell is kind of an identification test for kindred spirits. If someone looks puzzled (or a little horrified), I know to ease up on the honest confessions. If someone nods in understanding (or their eyes fill with tears), I know I've found one of My People.

Here's my standard answer when someone asks what exactly I mean by referring to myself as a slob. Like, how bad was it? I say, "It wasn't like I couldn't have anyone over. I just needed two weeks' warning to be ready. I'd spend the first week 'decluttering' (which meant shoving everything into my bedroom where I could lock the door), and the second week I'd clean (because I couldn't really clean with clutter everywhere). *That's it.*"

I still prefer a fifteen-minute warning, but surprise visits used to terrify me. The absolute dread I felt when someone casually mentioned stopping by my house affected me physically. I cried many tears and wailed "Why am I this way?" many times

while (literally) throwing months' worth of built-up mess into the nearest room with a door I could close.

I acknowledge that the confession in the last paragraph made some of you uncomfortable. I needed to say it though—just in case you made it all this way through the book thinking I was talking about Cute Messy, like windblown hair or jauntily placed table decor. When I say messy, I mean messy. Like, "How does anyone let it get this bad?" messy.

I felt frustration and bewilderment over the state of my house at all times, but the fear of someone outside our immediate family seeing it made me radiate with shame. The state of my home was my humiliating secret.

Jesus at the Door

I bring up my doorbell phobia for another reason. I have multiple clear memories from childhood of Bible teachers talking about the need to be ready to "open the door" to Jesus. Some talked about Zacchaeus, who had no idea Jesus would be "comin' to his house todaaaaayyyyy." Others quoted Revelation 3:20, which says (in red letters), "Here I am! I stand at the door and knock. If anyone hears my voice and opens the door, I will come in and eat with that person, and they with me."

More than one of those childhood teachers tried to help us kids envision this scenario by telling us to imagine the president of the United States coming to our town and showing up at our house. Wouldn't we want to be ready? Wouldn't it be *awful* if the president showed up at our door and we were too embarrassed to let him in because we hadn't cleaned our room? And Jesus is

a way bigger deal than the president, so shouldn't we be ready for Him at all times? Shouldn't we keep our rooms and our lives clean so we're ready to invite Him in?

I know kids don't always hear exactly what adults are trying to say, so I'm not criticizing those teachers. I'll only clarify and correct what *I* heard. When I heard teachers talk about Jesus knocking on my door, I pictured my messy room that gave my mother fits. I saw my bedroom that defaulted to Disaster Status whenever given the opportunity. That room never *just stayed clean* like my friends' rooms seemed to stay clean. There were clothes on the floor and stuffed animals piled high and craft projects strewn about and forgotten. And sometimes, half-drunk glasses of milk that I found only after they'd started to reek, hidden behind clutter on a shelf. Because this was the picture inside my head while the children's church teachers urged us to be ready for Jesus, I heard that I should hope Jesus never showed up at my door. Because if He did, I'd be too embarrassed to let Him in.

The untruth I internalized was that letting Jesus see my mess wasn't an option. I should try to do better. I should fix this messiness problem so I could let Jesus in if He ever happened to knock.

I understand this example was meant to encourage children to do what's right. I should keep my house/heart clean so I'd feel great about opening my door/heart wide to Jesus anytime. If I was ready (or my room was perfect) all the time, I'd never be embarrassed to let Jesus in if He showed up. But as an inherently messy kid, this particular image of Jesus knocking at the door was, honestly, terrifying.

The inherently messy person has tried and legitimately doesn't understand how her house keeps falling back into shambles. She can't figure out why her logical plans to change herself

and her home never work. She knows that nine out of ten unexpected doorbells send her hiding in the back room with the lights out, pretending she's not home. She's embarrassed for the postal worker to glimpse the inside of her house when she has to open the door to sign for a package. The thought of *Jesus* asking to come inside is absolutely horrifying.

The message I got, whether intended or not, was to clean up for Jesus: "Get your problems taken care of so you won't be ashamed to have Jesus come into your life. Your goal and motivation for doing what's right should be to impress Jesus or at least to not feel embarrassed in front of Him. Hide the mess. Don't let anyone see it, especially Jesus."

Jesus Wants to Come Inside, Even If the House Is a Mess

I met Jesus as a child, but I got to know Him on a personal level as an adult. The beauty of knowing Jesus personally, which happened when I started reading the Bible for myself, was finally learning that this childhood impression of Him was wrong. Thinking I should hide my mess from Jesus was the opposite of what I needed to do.

Thinking about Jesus in this way was, honestly, dangerous. Nowhere in the Bible does it say that I need to get my life together before coming to Jesus. It just says come to Jesus. Open the door if He knocks. He won't be surprised or shocked or horrified by your mess. He wants to come inside and spend time with you. He wants to shine His light over it all. Not to shame you, but because His light is the only thing that can make it better.

And to be clear, I'm not just talking about dirty dishes, piles of laundry, and a garage full of clutter. We've already established that Jesus doesn't care about your messy house. I'm talking about all of it. All of you. Your non-sin struggles and the sins you fear could never be forgiven.

Open the door if Jesus is knocking. There's literally nothing you need to do first before you open up your heart and let Him inside. He wants you to let Him love you exactly as you are today. At this very moment. Nothing you do can scare Jesus away from you.

If you think you have to fix your life before you come to Jesus, then you don't fully understand what He's asking of you. He's asking for all of you, whatever that includes. He's asking you to let Him handle it all. In Matthew 11:28–30, Jesus said,

> Come to me, all you who are weary and burdened, and I will give you rest. Take my yoke upon you and learn from me, for I am gentle and humble in heart, and you will find rest for your souls. For my yoke is easy and my burden is light.

Once you open the door to Jesus, everything will change. You'll start down the path of understanding His heart, and your heart will change as you go. But first go ahead and open that door. Welcome Jesus in.

Finding Your Why

In decluttering circles, there's a lot of talk about "finding your why." The idea is that knowing why you hang on to things so

tightly will help you let go of them. Or that understanding why you want to change will help you change. That's fine, but I generally don't teach about finding your why. I just teach decluttering.

What I have found is that most of us have plenty of clutter to purge before we even get to the stuff that might benefit from knowing our why. I could get rid of a lot of my stuff faster by *not* taking the time to stare off into space asking myself why it was there. I can wonder why I put the empty fettucine box back on the shelf, but I can throw it in the garbage much faster than I can answer that (unanswerable) question.

I learned my why as I decluttered. I learned it as I threw away trash. I learned my why while I did the easy stuff and answered my fact-based, nonemotional decluttering questions. I figured out what was important to me as I blamed containers for not being big enough to keep things that weren't as important.

I had lived with my house being (mostly) decluttered and functional for almost an entire decade when it hit me that my why wasn't what I would have assumed it was in the beginning. For the first few years of my deslobification journey, I kept hoping to get to the point where I was a different me. A new version of me who didn't struggle anymore and whose house looked like the pictures I saw in magazines or on Pinterest.

I'm so thankful I wasn't focusing on that why, because I understood my real why only after a lot of the clutter was gone. Having my house under control lets me be *me*. And I am someone who enjoys things that have nothing to do with my house. I like writing. I like making videos and podcasts. I like being able to volunteer my house for a bunch of girls to get ready for prom when the original prep house loses power during a thunderstorm. I like being able to take advantage of the once-in-a-lifetime

opportunity to invite my college friends (after many years of missed May Trips) to my house when I realize it's in the path of totality for a solar eclipse. I like being able to do that without panicking or needing to rent a storage unit to make space for them to sleep. I like being able to hire a house sitter to care for my naughty dog who got banned from boarding at the local kennel. If you truly relate to where I was before I got my house under control, you know that the idea of someone staying in your home while you're not there is the promised land of many a hopeful declutterer. I wanted to get my house under control so I could do the things that make me . . . me. I didn't want my house to hold me back from living the life I wanted to live.

Ultimately, my why is eternal. I always say that the things I teach about housekeeping and decluttering boil down to reality acceptance. Accepting that my relationship with Jesus is the only thing that will last for eternity is the ultimate reality acceptance. And knowing I'll spend eternity with Jesus is the ultimate freedom to be who God created me to be.

Whatever your why, whether it's trauma or a chemical imbalance or your love of history or possibilities or anything else, Jesus won't glance askew at your stuff or the reason for it when you bring Him into your life.

This book is coming out in 2025. That means (almost) every single person capable of reading it has been through a traumatic event. One definition of *trauma* on Google is "a deeply distressing or disturbing experience." I once heard trauma described as any situation where life was one way before the event and then completely different after. We all lived through a pandemic, so we've all experienced trauma. Whatever your views or feelings or experiences of the pandemic, it was life-altering in a way that

I never would have considered possible. One of my kids ended high school and started college in 2020. His life path was literally altered by something completely outside anyone's control. My father's life path was literally altered by the Vietnam War draft. It happens. Life happens. The path is altered more dramatically for some of us than for others.

I finished writing the original draft of this book in the first week of March 2020. I thought I'd finish it up when my kids went back to school after spring break. Har-dee-har-har-har. They never went back to school that year, and the following school year was a roller coaster. It took me two years to come back to this manuscript, and more years to finally finish it.

Coming back to this manuscript was a little scary. What if everything I'd written about washing hands didn't hold up after going through a global pandemic? But it did. The book was never about washing hands or washing dishes or throwing out trash or decluttering closets. It was about Jesus. Jesus and His passionate desire for our hearts to be turned passionately to Him. And that holds up just fine.

One Last Important Word: Community

*O*n page one, I wrote, "This is a book about experiencing God's grace, using an oddly specific, strangely divisive example from my own life. This particular example feels both too unimportant and too daunting to be *the* example, but it's the example God gave me to share."

If keeping your home under control doesn't keep you up at night, you've probably thought, *Wow, these are a lot of thoughts about something I've never thought much about.* But if you've worried about your house and how Jesus feels about it more than you wish you did, I hope you've felt your shoulders and heart relax.

I'm so thankful for this opportunity to have shared the deepest, most crucial part of me, my identity as a Christian, even if the way I got here was sharing my deepest, darkest source of shame. I'm thankful to God for having a more fulfilling and more fun plan than mine, and I'm thankful to you, my community.

Community changed everything for me and my home. Writing helped me focus, but the people who read my writing and joined the ride kept me going.

Community gave me freedom, and community gave me strength. Community helped me find peace. Through

community, I was able to see my situation and my created-on-purpose quirks from a bird's-eye view instead of from the middle of my cluttered living room. The shift in perspective when I realized I wasn't alone in my mess and confusion changed everything. The juxtaposition of "too unimportant and too daunting" had me stumped, but community unstumped me.

I recently realized I never would have taught anyone the Container Concept had I not shared it in the real-time-learning-it-for-myself, I'm-not-teaching-anyone-anything way I originally did. It's too basic, too embarrassingly "obvious." If I hadn't been encouraged by people reading my real-time realizations, I'd have gone on assuming I was the only person alive who didn't already know that trying to keep more stuff than I had space for was never going to work. The worldwide chorus of "This changes everything for me too!" showed me that I wasn't the only one who didn't know and that someone needed to spread the word.

This crucial piece of the clutter puzzle had been kicked under the couch, and I had to be willing to get down on the floor and reach through the cobwebs to get it out. Community makes me willing to do that.

Whatever your struggle, whether it feels huge or small or too huge and too small at the same time, God's grace is there for you. I pray you find the community you need where you can share honestly and move forward. This is the intended beauty of the church. Imperfect people, honest about their struggles and need for Jesus, come together in unity to demonstrate Jesus' love to one another.

However you came to read this book, I pray you leave it feeling loved, with more understanding of, and confidence in, God's grace.

Acknowledgments

I don't love writing acknowledgments. It's not because I'm not thankful. The ways people have helped me throughout this process are impactful and nuanced, and I'm someone who likes to overexplain with all the details, but my editor won't let me take another twenty thousand words for that.

Also, I know I'll forget someone.

First, I thank God for showing me what He showed me, which I shared in this book. I rested in these truths long before I wrote them down. And even though I groaned audibly when He made it clear that this was supposed to be a book, I'm thankful for the opportunity to share the only thing that, ultimately, matters.

Second, I thank my husband, Bob, for cheering for me through every little step of the last fifteen years while I've shared our mess on the internet. Thanks for being proud of me and not mad when I leave the cabinet doors open. I'm sorry you keep hitting your head, but also . . . you should probably be more careful to not run into them.

Third, my kids. Jackson, Reid, and Presley. I used to call y'all my life's work. I guess that's true to a point, but I now know that I

was just a little part of the amazing lives y'all are leading on your own. You're my favorite people in the world (along with Dad, of course) to be around, and you are occasionally even funnier than me. Thanks for teaching me so much about God's love for me and the beauty of letting go of my plans. I pray you do great things for God as He does great things in you.

Next (I'm tired of numbering), my mom and dad. Thanks for making me feel completely and totally loved and accepted for who I am. I truly believe that your parenting gave me the freedom to share my mess with the world, even though you tried your very best to parent that mess out of me. That means all the people who've been helped by me sharing have been helped by you. Thanks for being my first readers of this book and for taking an entire week to go get Reid from college so I could finish it. I respect and trust your input so much.

My team at Pink Bandana Media. Jennifer, Linda, and Candace, thank you so much for making it possible for things to keep going while I "crawled in a hole" to write this book. Thanks for understanding the vision of what I do and helping to make that vision clear to more people.

Those dear and trusted and God-loving friends who agreed to read this book to check for theological accuracy and point out parts that made you cringe or fall asleep. Melissa, Elysia, and Caroline, I appreciate your help and I am so thankful God joined our paths.

Also, Reid White and Bob White, for reading the manuscript too for the same reasons. It felt weird to put you two in the group with all my mom friends, so you get your own line.

My agent, Jenni Burke. Your understanding of the need for this book and passion to make it happen are truly a treasured gift.

Acknowledgments

My team at W Publishing. Thanks for letting me write the book I felt so strongly God wanted me to write. Damon Reiss, Carrie Marrs, thanks for saying yes. Lisa-Jo Baker, thanks for jumping in with excitement and making me feel so understood in the middle of this project. Janna Walkup, Jocelyn Bailey, and Lauren Bridges, thanks for your careful input and encouragement. And thanks to all the others who help get this book into the hands of people who desperately need to know that Jesus doesn't care about their messy houses. May it be a breath of fresh air and of life.

Notes

1. "Cleanliness Is Next to Godliness," Dictionary.com, accessed July 1, 2024, www.dictionary.com/browse/cleanliness-is-next-to-godliness.

About the Author

Dana K. White is the creator of the No-Mess Decluttering Method and (much to her own surprise) a Decluttering Expert. Dana shares realistic home management strategies and a message of hope for the hopelessly messy in her books *Organizing for the Rest of Us, Decluttering at the Speed of Life* (a *Wall Street Journal* bestseller), and *How to Manage Your Home Without Losing Your Mind*. Dana teaches her strategies through her blog, podcast, and videos at ASlobComesClean.com and trains coaches in her unique decluttering process at DeclutteringCoaches.com.